GHOSTS OF ATLANTA

GHOSTS OF ATLANTA

PHANTOMS OF THE PHOENIX CITY

REESE CHRISTIAN

Haunted America

Published by Haunted America

A Division of The History Press

Charleston, SC 29403

www.historypress.net

Cover design by Marshall Hudson

First published 2008

Manufactured in the United States

ISBN 978.1.59629.544.5

Library of Congress Cataloging-in-Publication Data
Christian, Reese.
Ghosts of Atlanta : phantoms of the Phoenix City / Reese Christian.
p. cm.
ISBN 978-1-59629-544-5
1. Haunted places--Georgia--Atlanta. 2. Ghosts--Georgia--Atlanta. 3. Atlanta (Ga.)--
History. I. Title.
BF1472.U6C496 2008
133.109758'231--dc22

 2008027631

Notice: The information in this book is true and complete to the best of our knowledge. It is offered without guarantee on the part of the author or The History Press. The author and The History Press disclaim all liability in connection with the use of this book.

CONTENTS

PREFACE

The South is known for its folklore, legends and haunted plantations almost as much as it is known for its culture of being laid-back and polite. Atlanta's ghost stories and horrifying history always lure the most curious folks who want to decipher the past while encountering a fright along the way. People come from the edges of the world to experience all of the great things that Atlanta has to offer, and more often than not they want to get a firsthand look at our culture of supernatural interaction.

As a lifelong resident of Atlanta, as well as a natural-born psychic medium, I have experienced many haunted locations and have lived to tell the tales. The dead have lessons about our past that they need to teach us, and they tend to linger in the locations of their untimely deaths. It is important that we learn from our ancestors and reap the rewards of their sacrifices so that we may live more enriched lives.

I have shared my culture and heritage with many people by taking them to these locations so that they could experience firsthand what a true haunted location feels like, while at the same time explaining to them the history behind the haunting. These locations are so filled with the energy of the dead that even the greatest skeptic walks away questioning his firm beliefs.

I have devoted my life to paranormal research, and given that I can communicate with the dead, I am fascinated by those who choose to stay behind and haunt locations once they have left their physical bodies. I

have visited and investigated every location that I've written about in this book, and I have been terrified by the supernatural occurrences at many of these locations, but the exhilaration of the experience always keeps me coming back for more. Now, I want to share the history and experiences with you.

ACKNOWLEDGEMENTS

I would like to thank the following people for helping me research, write and provide photographs for this book. Thank you to my family (Mom, Roxie, Kenny and kids) for your support, help, advice and love. Thank you to Denise Roffe for your research, photographs, support and friendship. Thank you to Magan Lyons and Alessandra Bosco of The History Press. And, thank you to Tim Hollis, Regina Wheeler, Ellen Archer, Liz Hood, Kevin Fike, Tracy Page, Scott Mahr, Willie Johnson, Kelley Swann, Cindy Horton, Asif Edrish, Edward Rainey, Jerry and Linda Love, Molly Fortune, Michele Schuff, David Moore, Kevin Kuharic, Allen B. Goodwin, Erica Flores, Hela Scheff, Judy Gaither Dial, Christine G. Whelchel and Lain Shakespeare, all of whom provided their own significant contributions. You all have my deepest appreciation. I also wish to thank Jana VanDyke and Patrick Burns for all of your professional guidance. And finally, thank you to everyone else who contributed to this book. Without all of you this would not have been possible.

INTRODUCTION

Allow me to take you on a journey through ten of the most haunted locations that Atlanta has to offer. Together we will explore all of the emotions brought on by love, loss, tragedy, war and vengeance, to name a few. It is through these strong emotions that ghosts tend to linger and dwell in the places that they once knew. Their need to address unfinished business rules their reasoning, and they simply cannot or will not move on to a better place until they have accomplished their goals.

I will introduce you to the restless spirits of disenfranchised Native Americans who were forced off of their land and died in the process of either fighting or fleeing; to Civil War soldiers who fought for their cause and died so young; to loving husbands, wives and parents who lost their loved ones to disease and tragedy; and even to a recently departed Atlanta mayor who loved his wife so much that he reached through the dimensions of time and space to communicate his wishes to her.

Some of these places are famous worldwide while others are not quite as well-known. However, they are all very haunted and are worthy of the attention of those who care. So, sit back and relax while I share with you some of Atlanta's most prominent history and haunted locations. The ghosts are still hanging around to share their stories—and maybe a good fright or two as well. On your next trip to Atlanta, make sure that you visit each and every one of them. They do tend to get quite lonely.

ANTHONY'S RESTAURANT

Formerly Known as the Pope-Walton House

Anthony's Restaurant is located in an upscale area on the north side of Atlanta, Georgia. Construction of this beautiful plantation home was begun in 1797 by a fourth-generation Anglo-American named Wiley Woods Pope in what is now known as Washington, Georgia, about 117 miles east of Atlanta. Once residing on a twenty-five-hundred-acre plot of land, the plantation was a thriving home to several hundred African American slaves. However, in 1865, during the aftermath of the Civil War while Union troops were infiltrating Georgia towns, soldiers came across this luxurious manor housing only a young mother named Mary Elizabeth Pope Walton, her infant daughter, Lula Belle Walton, and her nursing slave girl, Sarah Walton. The Union troops raided and looted the beautiful home, but left it intact and did not burn it due to the infant child. Later that same year, the man of the house, John Howard Walton, finally returned from the war. Unable to pay the now-freed laborers, he lost the estate to his father-in-law, Wiley M. Pope, who completed the house and lived there until 1891.

In 1967, the home was meticulously moved over a three-year period to where it now sits on Piedmont Road in Atlanta, Georgia. It has been completely restored to its earliest glory using as much of the original materials as possible. The mansion is now utilized as an upscale, fine dining restaurant named Anthony's, and the only addition has been a beautiful banquet hall built in the 1970s that is lovingly referred to as the

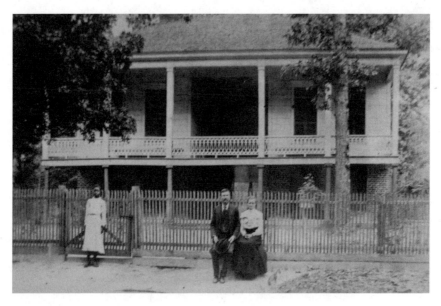

Pope-Walton Plantation, 1840. *Photo courtesy of Anthony's and Denise Roffe.*

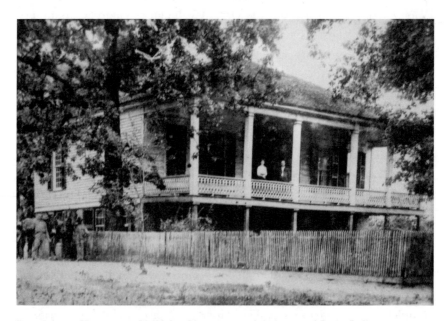

Pope-Walton House, pre–Civil War. *Photo courtesy of Anthony's and Denise Roffe.*

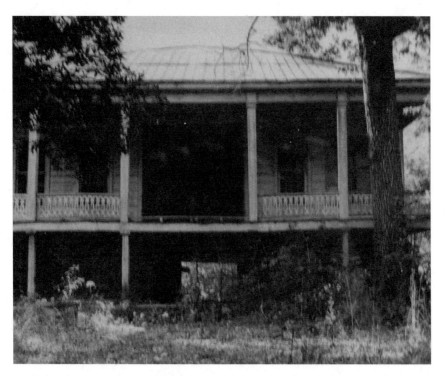

The manor prior to restoration. *Photo courtesy of Anthony's and Denise Roffe.*

"Ladybug Room" in honor of the very last hostess of the manor, Anna Almeda Pope, the daughter of Wylie M. Pope and Almeda A. Wooten, who lived there until 1920. Her nickname was Ladybug as a child, and as she grew older it evolved into Aunt Lady.

Many people have claimed to have had paranormal experiences throughout the decades that Anthony's has been open, and oftentimes the stories are very similar in nature. One such story is that the sound of bells can be heard late at night when there are no bells ringing or jingling anywhere. The belief is that this is Lula Belle running and playing in the house. When she was a young girl, her mother would sew small jingle bells into her petticoats so that she could keep track of her in the massive plantation, and now the young child's spirit is believed to be playing with the living by letting us hear her bells.

Whatever happened to Lula Belle Walton is a mystery. Although her name appears on the 1880 census of Wilkes County, she seems to

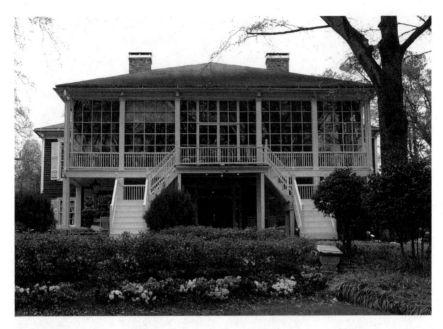

Anthony's Restaurant as it stands today. *Photo courtesy of Anthony's and Denise Roffe.*

disappear after that. She was listed as a white female, sixteen years of age, "keeping house." I have searched various Georgia state and nationwide vital statistics records. There is no marriage record for Lula Belle Walton to be found anywhere in the United States. There is also no known grave of Lula Belle Walton.

Given what we know of the aftermath of the Civil War, I can't help but wonder if Lula Belle might have fallen in love with a Union soldier. Perhaps she left the state with him or married in secret, fearing retribution by her family. Whatever the reason for her disappearance, it seems that Lula Belle is at home again playing at Anthony's.

However, Lula Belle is not alone. In the foyer of Anthony's, there are several historic photos hanging on the wall. One of them is a portrait of Mary Elizabeth Pope Walton in her wedding gown. It seems that she has been revealing herself through the years to many people in windows from afar, and she has been known to interfere with electrical activity, including turning lights on and off. The light switches that control the enormous upstairs chandeliers are on a back wall at the top of the stairs. The controls are dimmer switches—round knobs that one can turn up

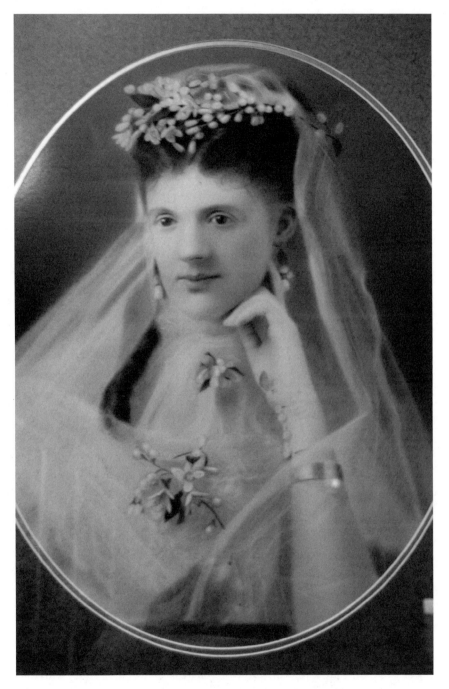

Mary Elizabeth Pope-Walton on her wedding day. *Photo courtesy of Anthony's and Denise Roffe.*

and down to dim and brighten the lights—but the buttons actually need to be manually pressed to turn the mammoth chandeliers completely on or off.

One reluctant witness said that as she was getting ready to leave one night, the "lady in white" passed her as she was coming down the stairs. Frozen in fear, the hostess watched as the translucent apparition made her way to the landing before she disappeared. Thinking that she was overtired, the hostess locked up the restaurant and walked to her car. As she was about to drive away, the upstairs chandeliers came on. Although she knew that no one else was in the house, she went back inside and up the stairs to check. When she was about three feet from the dimmer switches, she heard the familiar "click" and the chandeliers turned off.

Maybe you'll meet Mary Elizabeth Pope Walton on your next venture to Anthony's Restaurant. I did. You'll want to look for electrical disturbances, apparitions in upper windows that can be seen from the outside of the home and the infamous "lady in white" figure that has been seen on the main staircase and in the upstairs foyer by many dining guests as well as the staff. She has never been known to purposely frighten or hurt anyone, so there's no need to be afraid of her. Or, is there?

No self-respecting Southern plantation would be complete without a cat or two milling about. In the 1800s, they were prized "working domestic animals" as pest control for rodents. During the same time period, cats were beginning to be bred for shows. Although the historic documents do not indicate that the Waltons or Popes were breeders, it seems that one furry plantation worker has never left.

Patrons and staff alike say that they have heard the soft mewing of a kitten at various times throughout the day at Anthony's. One customer was enjoying her rack of lamb when she felt a cat rub on her leg under the table. Thinking that it was quaint that Anthony's had such a friendly mascot, she continued to enjoy her lunch. At the end of the meal, she mentioned to the server that she had thoroughly enjoyed her dinner and had also enjoyed the cat. The staff member explained that no living cat resides at Anthony's. Upon the woman's insistence, the staff searched for that cat for about fifteen minutes before realizing that there were no open windows or doors through which a real cat could have exited, nor were there any hiding spots into which it could have slipped. They finally

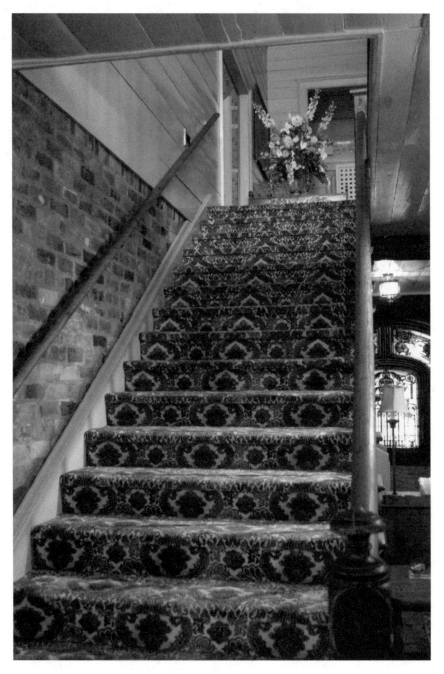

This front staircase is where the "lady in white" is often seen. *Photo courtesy of Anthony's and Denise Roffe.*

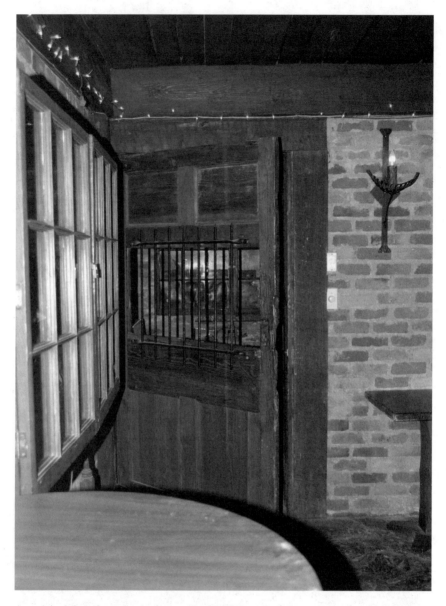

An original door from the Andersonville Civil War prison camp. This room, the wine cellar, is where paranormal activity is often reported. *Photo courtesy of Anthony's and Denise Roffe.*

gave up. The ghostly presence has been witnessed all over the mansion, including the last stall in the ladies' restroom, where it is believed to be the invisible force unraveling the toilet paper roll.

Another of the plantation's domestic servants was Lucinda Pope. Lucinda was a freed black slave living on the property in 1870. She is listed on the 1870 census as a twenty-eight-year-old domestic servant. Several of Anthony's staff members have seen an apparition of a young black woman dressed in Civil War–era attire going about duties throughout the house. She has been known to appear in the wine cellars, particularly in the smaller of the two and usually standing by a curious door.

The city of Andersonville is located about 147 miles from Anthony's. During the Civil War, there was a large prison camp erected in Andersonville, where approximately forty-five thousand Union soldiers were confined and, of those, thirteen thousand died in the prison camp. During one of the camp's renovations, several of the prison doors were replaced. Although it is unclear how it came to be, one of the prison doors found its way into the small wine cellar at Anthony's. Perhaps that is why Lucinda is seen standing by it—she must know that it doesn't belong to the house.

There seem to be many ghostly tales of apparitions, shadowy figures and such at Anthony's. However, the history of the mansion and the families that lived there seem to live on amidst the beautiful brickwork, crown molding, chandeliers and high ceilings.

The next time you want to treat yourself to an exquisite dinner at an upscale, fine dining restaurant, and you'd like a little history or perhaps an apparition with your filet mignon, Anthony's is absolutely the perfect place to please both your palate and your ghostly curiosity.

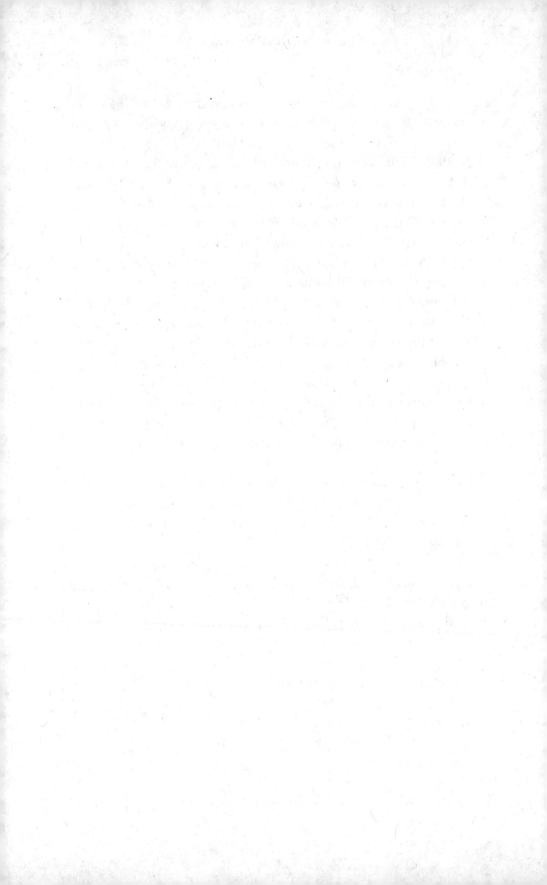

THE FABULOUS FOX THEATRE

S hrouded in secrecy, myth and legend, Atlanta's Fabulous Fox Theatre is located at the corner of Peachtree Street and Ponce De Leon Avenue in the Midtown section of Atlanta. The idea of its conception was born in 1889, but it took thirty years to come to fruition.

A gathering of thirty-two Knights Templar and Scottish Rites Masons met to organize the Yaarab Temple Shrine to house meetings of the newly formed Ancient Arabic Order of the Nobles of the Mystic Shrine, more commonly known as the Shriners, which is a branch of Freemasonry. The Shriners adopted a Middle Eastern theme and referred to their meeting halls as temples or mosques. It should be understood that this was not meant to be a religious organization that worshipped at these meeting halls. In fact, these were places of business and charity.

The land upon which the Yaarab Temple Shrine (the Fox Theatre) was to be built had been known sixteen years earlier as Fortification K. This was a holding fort for Confederate soldiers fighting off the Union army in a failed effort to defend Atlanta. As one may guess, there were lost lives and bloodshed on the property. One of the ghostly tales that abounds is that a Confederate soldier has often been seen by staff in the basement area near a door that blocks off an old, decrepit tunnel that was utilized during the Civil War. He is always seen standing guard at this entranceway. There have also been sightings of a Confederate soldier, possibly a different one, looking into the windows of the Fox building from the outside. He has

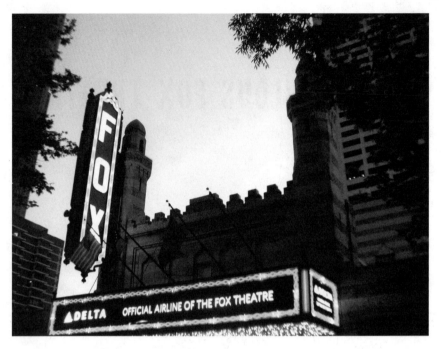

The Fabulous Fox Theatre of Atlanta. *Photo by Reese Christian.*

frightened many patrons, as well as staff, who immediately realize that they are looking at a ghost.

During the 1880s, there was a beautiful mansion built on the property that would eventually house the Fox Theatre. This glorious home was constructed for Colonel Willis E. Ragan, and although I can't find whatever came of the home, there is another very popular Fox Theatre ghost story that is believed to have begun on account of one of its occupants. The story entails a woman by the name of Anna Ragan, who at one time owned and lived in this home. She is believed to have died in the home and is now seen by entertainers in the women's dressing room number 42. Is it possible that Anna wanted to be a performer and this is her way of acting out that fantasy? Nobody knows for sure; however, each year the Fox Theatre entertainers bring her flowers on the day that they have dedicated to honoring her death, and Anna shows her appreciation in various "haunting" ways. She is known to move things around in the dressing room, she occasionally appears as a translucent figure and there are times when one can hear the whisper of her voice. There was even

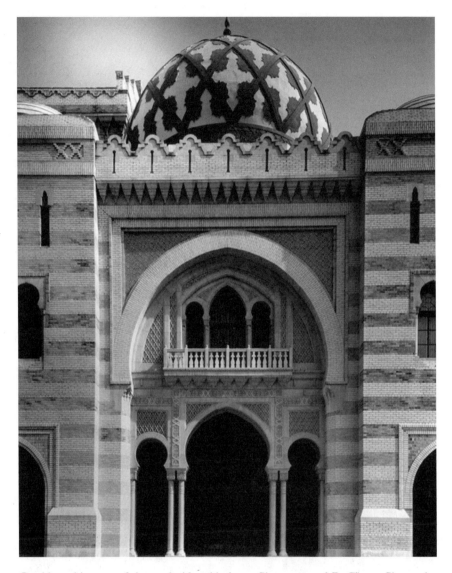

Outside architecture of the south side, with dome. *Photo courtesy of Fox Theatre. Photographer, Michael Portman.*

an electronic voice phenomenon (EVP) recording that captured what is believed to be Anna responding to the question, "Does the lady who used to live here get her flowers?" After a brief moment, one can hear a faint female voice reply, "Yes."

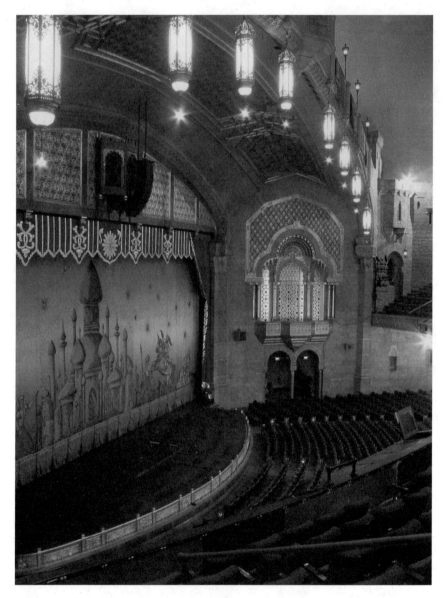

Inside the theatre. *Photo courtesy of Fox Theatre. Photographer, Sara Foltz.*

As we return to the Shriners of the late 1880s, their next order of business was to erect the most magnificent mosque in the world, and by 1925 their plans were underway. They began a search for an architect who could produce their vision, and in 1927 they finally settled on Oliver J. Vinour and P. Thornton Marye, whose interpretation was a very

elaborate, flamboyant version of Islamic, as well as Egyptian, architecture. That same year, the Yaarab Temple Shrine entered into negotiations with Fox Film Corporation's theatre division and eventually agreed upon a long-term lease on the civic auditorium. Fox Theatre was born.

The Fox opened its grandiose doors for business on Christmas Day 1929, just two months after the stock market crashed. Sadly, after only 125 weeks of showing films and live theatre, the Fox declared bankruptcy. It continued to flounder and change management until the 1940s, when it began to see life revitalized as it became the most popular dance hall and host to the biggest swing bands of the era. The Fox Theatre thrived for two decades, but the civil unrest of the 1960s brought the Fox to the brink of closing yet again.

By 1974, the Fox announced it was closing its doors forever, and it was actually going to be demolished and turned into a parking lot. However, due to a grass-roots campaign, the Fox was saved and placed on the

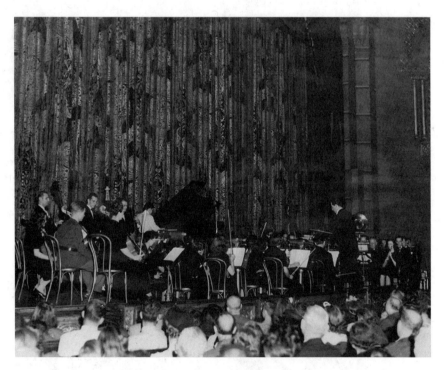

Fox stage. *Photo courtesy of Fox Theatre. T.H. Read images used by kind permission of Fred and Missy Leypoldt.*

Fox seating. *Photo courtesy of Fox Theatre. T.H. Read images used by kind permission of Fred and Missy Leypoldt.*

Inner hall. *Photo courtesy of Fox Theatre. Photo by Michael Portman.*

National Register of Historic Places. By 1989, the Fox was also designated a Landmark Building of Atlanta, and in 1991 it had the honor of being designated a National Landmark Museum Building.

The Fox's new purpose was no longer to be a movie theatre, but a vast omnibus of performing arts, and it is still thriving in this capacity today. Almost every major entertainment star and many political leaders have

performed or spoken at the Fabulous Fox Theatre. As an Atlanta native, I can tell you that the Fox is very much a part of my own history and heritage. I grew up attending grand events, galas and concerts at the Fox. As a medium, I can tell you that the Fox is an amazing place to encounter spiritual energy. I've heard that a few entertainers were so affected by the spiritual energy and haunting feelings that they were afraid to return. I wonder if they did.

As I spoke to Molly Fortune, a staff member of the Fox Theatre, she shared with me an interesting paranormal event that happens on a regular basis down in the boiler room. Many years ago, when the boilers were still run by coal, there was a male employee who worked in that capacity. He also had a cot set up in the boiler room so that he could sleep there as needed. This gentleman eventually passed away, but as many workers can attest, he is still there minding the boilers, and he is also quite aggressive toward male workers. Several of the workers have reported that the scaffolding would begin to shake, faucets inexplicably turned on and off by themselves and all things electrical had a mind of their own! However, when women are in the area, they tend to feel a sense of wellness and of being safe. I suppose he feels territorial and protective of his space and of the women he thinks he needs to protect.

In 1996, the Fox suffered a four-alarm fire that fortunately did not damage the most prevalent areas of the building. One reason that the fire was controlled so quickly was due to the theatre's only resident, Joe Patton. Mr. Patton served as technical director from 1974 until 2004 and dedicated his entire life during that time to the maintenance and preservation of the Fox Theatre. He has dedicated so much to the Fox that the theatre granted him lifelong permanent residency in the only 3,640-square-foot apartment, which was transformed from old Shriners business areas and is where he resides today. His apartment has secret doors and entranceways to different areas of the Fox Theatre, and I'm sure it is much like a modern-day castle, where he sits comfortably as king.

Another common ghostly tale that abounds at the Fox is one of a dog's barking late at night—midnight to be exact—inside the building. Resident Joe Patton had a dog that died one night at the stroke of midnight in the lobby during a Rolling Stones concert, and ever since that night many security guards and staff members have heard the sound of a dog barking

Lower men's lounge, Egyptian influenced. *Photo courtesy of Fox Theatre. Photo by Michael Portman.*

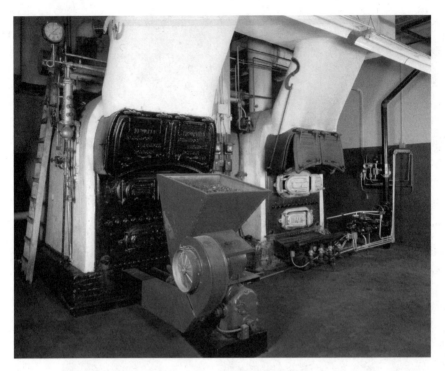

Fox boiler room. *Photo courtesy of Fox Theatre. Photo by Michael Portman.*

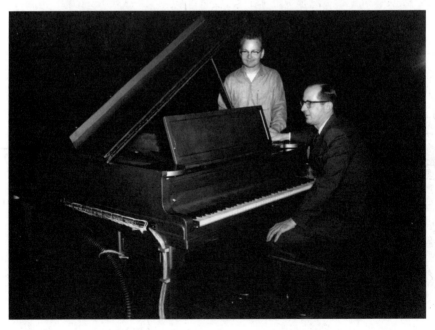

Joe Patton (left) and Bob Van Camp (seated). *Photo courtesy of Fox Theatre.*

within the building after hours, but find no canines in the vicinity. It appears that this particular vestibule of man's best friend is not yet ready to leave his master. However, I would bet that once Mr. Patton physically leaves this world, he too will be seen in a shadowy stance and heard in a whisper as he haunts his beloved home, the Fox Theatre.

It is very interesting to note that the Fox has housed the "Mighty Moeller" pipe organ, better known as "Mighty Mo," since 1929, but in 1954 the pipe organ was so neglected that it completely stopped working. It wasn't until 1963 that this magnificent organ, with pipes as large as thirty-five feet, was restored and able to play. Lone resident Joe Patton, who was not yet residing at the Fox, was the force behind the Mighty Mo restoration. Once restored, master musician Bob Van Camp was

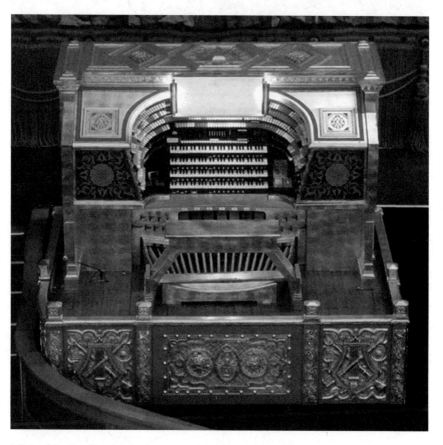

Mighty Moeller Organ, also known as the "Mighty Mo." *Photo courtesy of Fox Theatre. Photo by Sara Foltz.*

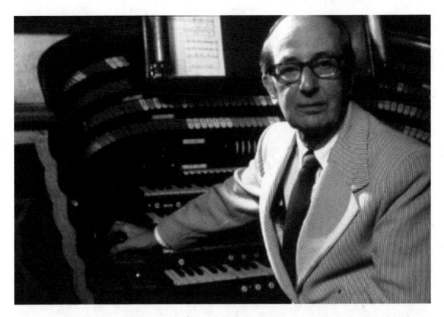

Bob Van Camp sitting at his beloved Mighty Moeller organ. *Photo courtesy of Fox Theatre.*

the in-house organist for more than a quarter century, and when he died his ashes were sprinkled in the attic directly above Mighty Mo by both Joe Patton and Atlanta Landmarks former board member Robert L. Foreman Jr., per Mr. Van Camp's request. Although I wasn't able to find any folklore or ghostly tales surrounding Bob Van Camp and the Mighty Mo, I assure you that he is there, still playing his instrument of passion, Mighty Mo. Meanwhile, Mr. Patton is still maintaining the goliath organ in pristine condition, and the rest is Fox history.

THE GAITHER PLANTATION

If you want a true representation of a Southern plantation, complete with heritage, ancestors and ghosts, then a thirty-minute trip east of Atlanta to Covington, Georgia, will act as your time machine and deliver you to a pre–Civil War farming lifestyle in which life was tough and family was all important. In 1850, William Hulbert Gaither, better known as W.H. Gaither, built a large farmhouse on his 875 acres of land that he had acquired from his father, Dr. Henry Gaither. W.H. married Cecilia Billups Wood in 1855 and they proceeded to have four children: Sara Clara (who died at only nine years of age and was named for W.H.'s mother), Mary Jane, Henry and William Jr., respectively.

The farm was a sustaining and even successful way of life as cotton was a fruitful staple of many farms and brought in much revenue. The family was very self-sufficient in a time when one had to live according to one's own means—this was still very much a rural area with no electricity or running water. W.H. died in 1890, and by the early 1900s boll weevils (cotton-eating beetles) had destroyed their cotton crops. Cecilia took her son W.H. Jr. and moved into the rural area of Covington, but they still kept the plantation.

In April 1888, Henry Gaither (W.H. and Cecilia's other son) killed his neighbor, George Smith, by hitting him in the head with a shovel. The two men had argued over the fact that Mr. Smith had cleared some land and had inadvertently burned some of the Gaither turkey nests in the brush

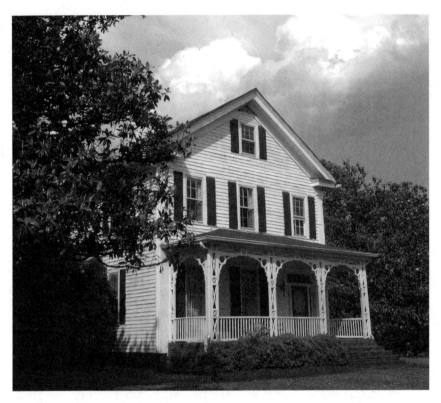

The Gaither Plantation farmhouse. *Photo by Denise Roffe.*

heaps. An argument followed, and then Henry hit George with a fatal blow to the head. Several of the town doctors were called, but none came. Henry escaped to Texas as a fugitive and was never heard from again. Cecilia died in 1916, and the property passed to her children. They filed bankruptcy in 1921 over twenty-eight dollars owed in back taxes, and they lost the plantation. The property then went through several owners, both private and corporate, throughout the years, including the McIntoshs, Siegfrieds and Welchels, to name a few.

The plantation consisted of the main farmhouse, the slave quarters, an outdoor kitchen, a barn and an outhouse. However, today the only original structures that remain on the plantation are the main farmhouse and a barn that was constructed on the property in 1950. The family cemetery is also located on-site, with several members of the Gaither family, as well as their former slaves, interred there. The concluding former buildings either

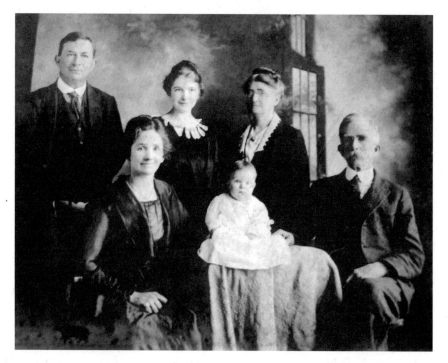

W.H. Gaither and family. *Photo by Denise Roffe, courtesy of Gaither Plantation.*

burned down or became dilapidated over time and were lost. However, recently many other structures have been brought in by different private parties and organizations to complete the historical Gaither Plantation. As a side effect of intermingling with old, historic structures, one encounters all of the ghosts attached to them as well.

There are many ghost stories that abound at this plantation, and some of the most prevalent stories, as reported to the staff, follow. Civil War reenactors who have camped out at the plantation have reported that they saw a man's spirit walk from the fireplace to the front window in the parlor of the main house and that this scene kept repeating itself as if it were stuck in a loop.

A soldier in a gray suit is seen in the basement as though he is hiding from the Union soldiers who did, in fact, invade the plantation searching for Confederate soldiers.

People have heard children talking and laughing but can't find any children present in the house or on the grounds. There happen to be three

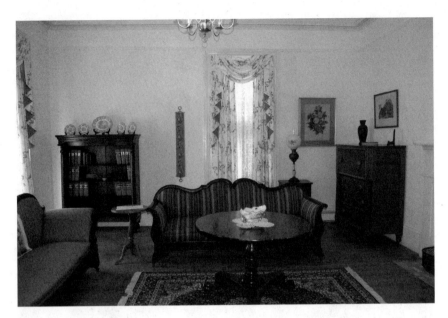

The front parlor, where a man's spirit walks. *Photo by Denise Roffe.*

child graves in the cemetery, in addition to the one of young Sara Clara Gaither.

Women who walk by or sit on the pulpit in the historic 1822 Harris Springs Primitive Baptist Church, which was relocated to the plantation in 2000, have had a feeling that someone is very dissatisfied that they are there. Some have said that they can feel the chair on the pulpit vibrate at times. It is known that during the church's early years the preachers would have been very upset by a woman's presence on the pulpit. It has also been rumored that there was a murder suicide committed near the back door of the church, supposedly due to a love triangle, and it appears that this malicious act has tainted the aura of the church. (In an interesting side note, the church still does not have electricity or indoor plumbing.)

The front upstairs bedroom of the main farmhouse has drawn the most attention. It belonged to Cecilia Gaither, and the rocking chair, which is not original to the home, has eerily captivated the minds of many individuals. It is often said that a woman rocking a child has been seen there and that the chair will begin rocking on its own. The chair is on loan to the plantation, and the staff recently learned that it belonged to a lady whose child had died.

The 1822 Harris Springs Primitive Baptist Church. There have been numerous reports of ghostly activity. *Photo by Denise Roffe.*

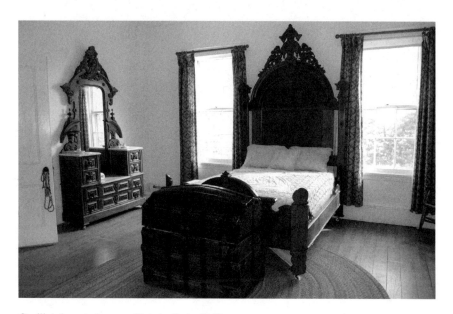

Cecilia's haunted room. *Photo by Denise Roffe.*

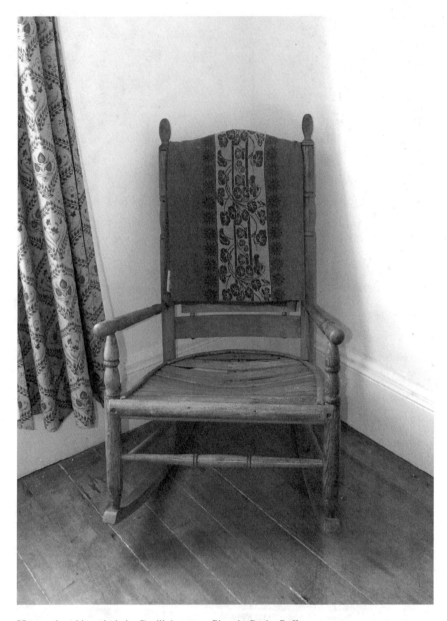

Haunted rocking chair in Cecilia's room. *Photo by Denise Roffe.*

Following are two separate direct accounts given by ladies, one of whom is a Gaither descendent, who lived in the Gaither Plantation before it was bought by Newton County and was declared a historical property.

My name is Judy Gaither Dial and I'm the great-great-granddaughter of W.H. and Cecilia Gaither, builders of Gaither Plantation. Following are a few of my experiences at Gaither Plantation.

Front Porch Swing

My father, Maurice (Reese) Gaither, lived at Gaither Plantation in the early 1930s. Although the Gaither family no longer owned the plantation, my father and his parents were allowed to live there for a while. He also used to take me down there when I was a child and would show me around, even though the place was owned by the Siegfried family. He always felt a connection to the land.

The first time I visited Gaither Plantation as an adult was shortly after Newton County had purchased the property in 1996. I had gone to visit on a June Sunday morning. Tracy, the caretaker, was inside working and I decided to sit in the swing on the front porch and enjoy the view. As I was sitting there, not moving, I closed my eyes and began to think about my daddy and how pleased he would be that the plantation was being restored. He passed away in June of 1985 and wasn't there to see the progress that was being made. I felt someone sit down on the swing beside me and the swing began to move back and forth, swinging. I opened my eyes, expecting to see Tracy, and there was no one there. I knew that I couldn't make the swing move because I'm only five feet tall and my feet don't touch the floor of the porch when I'm sitting in the swing. I jumped up and ran inside to find Tracy. When I found her I was nearly speechless. She asked me what happened and all I could say was, "The swing." She smiled and said, "I know. Did you feel someone sit down beside you and start to swing?" I nodded yes and she said, "It happened to me, too."

I fully believe that it was my daddy who sat beside me on that swing. I felt such peace when I thought someone had sat down with me. It's hard to explain, but I was never really afraid, just shocked, I guess. I still feel very close to my daddy when I'm at Gaither Plantation.

Front porch swing. *Photo by Denise Roffe.*

Rocking Chair in the Upstairs Front Bedroom

The rocking chair in the corner of "Cecilia's room," the upstairs front bedroom, is on loan to Gaither Plantation from a family in Mansfield,

Gaither Plantation before restoration. *Photo by Denise Roffe, courtesy of Gaither Plantation.*

Georgia. *The chair has a long history of rocking babies, some rumored to have been rocked by their mothers as they were dying.*

There was a Confederate reenactment being held at Gaither Plantation, again, shortly after Newton County had purchased the property. The reenactors camped at Gaither Plantation during the weekend of the reenactment. Several of the campers asked who lived in the house and were told that no one lived there. They then asked who spent the night in the house that Friday night. Again, they were told no one and were asked why they wanted to know. All of the people who asked gave the same story of seeing a woman walking back and forth from window to window holding a baby.

That same day, Saturday, tours of the plantation house were being given. As one of the guides brought her group into Cecilia's room, a female guest quickly backed out of the room. The guide went to check

on her in case she might be ill and the woman told her she couldn't enter the room. The woman told the guide that she was a seer and that when she looked in the bedroom, she saw the image of a woman rocking a dying child. I can't substantiate that claim, but I do know that I've seen the chair move on its own. I've also been told that spirits can attach themselves to an object and go where it goes.

Voices

There have been many children raised at Gaither Plantation and lots of fun and good times. There have also been several children to die there. In February of 2003, I was at Gaither Plantation to give a tour to a group of eighth-grade students from a local middle school. While waiting for the students, the caretaker at the time and I sat in the sunroom area looking across the fields and talking about some of our experiences at Gaither Plantation. The time came for the students to arrive and he and I heard a man and woman talking and children laughing. Thinking our guests had arrived we went down the hall to the front door. When the caretaker opened the door to the front porch he said, "Miss Judy, there aint no buses out here." Still hearing the laughter, we went to the dining room and looked out thinking the buses had parked on the side of the house. Again, there were no buses. I can assure you, however, that even though there was no one in the house but the caretaker and myself, we both heard the voices of a man and woman and the laughter of children. Our guests arrived about ten minutes later.

Cecilia

Cecilia and W.H. Gaither are my great-great-grandparents and they built Gaither Plantation and raised their family there. I had the privilege of participating in a paranormal investigation of Gaither Plantation in March of 2006. During the investigation of Cecilia's bedroom, I talked aloud to her, telling her I loved her, thanking her for allowing us to visit her home and asking if she had anything to tell me. While the investigation was going on, several of the investigators used small audio recorders in an effort to pick up EVPs or electronic voice phenomena.

Often during an investigation when questions are asked aloud, there is no audible response, but when the recordings are replayed, you can hear the spirit voices responding. As I was talking to Cecilia, I felt a cold sensation go down my spine, like someone touching me. The technicians detected a noticeable drop in temperature around me. My body temperature and that of one of the investigators, who was standing near me, also dropped. As I felt the cold, I said, "There it is," meaning the cold touch. When the audio tape was replayed, I could be heard saying "Grandmother, I love you. Oh, there it is." The next thing heard on the tape is an older female's voice saying, "I love you, too." I fully believe that was my great-great-grandmother telling me she loved me. I believe that my great-great-grandmother's spirit stays at Gaither Plantation because her husband and two of her four children are buried there, while she was laid to rest in the family plot in the Covington City Cemetery.

Here is another firsthand account of a former resident of Gaither Plantation, Christine G. Whelchel.

Ralph Whelchel bought 638 acres from a Mr. McIntosh, who lived in Mansfield, in the fall of 1949...a farm called the "Hub Gaither Place." He had been searching for a farm suitable for growing cattle and the new grass called Ky. 31 Fescue. This grass would grow and stay green in the winter, providing year-round grazing for cattle. Ralph was delighted to find five acres of the grass flourishing near a creek on the farm, the first planted in Newton County, so he was told.

The grass had become very popular. There was no place to take the seed for drying, so we cleared the farmhouse living room and hall and three rooms of a nearby tenant house. After spreading seed about a foot thick on the floors, we "plowed" through the seed a couple of times a day (sometimes more often if the weather was damp and hot) by sliding our feet along the floor. By making the "rows" closer together, all the seeds were shifted about and encouraged to dry without molding. Sounds difficult, but the seeds were light and the worst part was getting shoes and socks full of scratchy seeds.

The house was in fairly good repair, although there was much that needed doing. It did have a good roof and seven useable fireplaces but

no bathroom. When we finally put in a bathroom, we found our many young nieces and nephews, all city reared and frequent visitors, much perturbed. They wanted nothing changed on the farm.

At sometime after the Gaithers owned the place (I think) it was vacant long enough for pines to sprout and grow to a height of the second-story windows. A man, who grew up nearby, remembered that as a youth he and neighbor boys chased some goats up the stairs and out the second-story windows.

All the rooms of the house except the one now used as a kitchen had walls and ceilings of the original plaster (made with horse hair so we were told). This plaster was more than half an inch thick and somewhat cracked, but mostly in fair condition. A tornado knocked the main chimney off in 1974, I think, demolishing the roof and ceiling of the upstairs back bedroom. Both upstairs bedrooms were redone at that time. The plaster was so skillfully repaired that it looked like new. I understand the man who restored the house for Mr. Siegfried removed all the plaster as well as the ten- and twelve-inch hand-planed boards which covered walls and ceilings of the kitchen. A pity! By the way, the house is so sturdily built that two people in the kitchen eating breakfast the morning of the tornado heard the noise, but felt no tremor through the building. They discovered the damage only when they went outside and found bricks scattered about the yard.

In the back upstairs bedroom, closets are on each side of the fireplace. The one on the left looks like an ordinary closet when the door is closed, but inside there was a crude stairway to the attic and also room for a few clothes. When I lived there, visiting children were always intrigued by the "secret" stairway. They were fascinated by a tale about Confederate soldiers being hidden in the attic. As I remember the story told to me—the lady of the house was feeding a small group of Confederate soldiers when she received word that a group of Yankee soldiers was coming. She realized that if there was fighting, her family would be endangered and the house would surely be burned, so she begged the Confederates to hide in the attic until the Yankees left. They were not discovered, but all the farm livestock, which had been hastily hidden in the lower area back of the house, was found and taken.

I understand the slave quarters were back of the house and that is probably true as there was a good spring (or springs) in the area now covered by pond water.

One room of the house, with its fireplace and two walk-in closets, was built for the mother of Mrs. Gaither who came from Virginia to live with her daughter, so we were told. We always called it the mother-in-law room. It was thought to have been added on after the main part of the house was built.

Across from it is a wing with two rooms which was apparently built sometime before the rest of the house, judging by the floor joist of large, rough-hewn logs. The room now used as a kitchen had walls and ceiling of ten- and twelve-inch hard-planed boards when I lived there and apparently at one time had not been connected to the adjoining room by a door, judging by the carpentry around the doorway. We thought it must have, at one time, been a pantry-storage area when the original kitchen was in back of it, and separated from the main house to lessen the danger of fire.

A large fig bush stood close to the house all the years we were there. It provided many gallons of figs to eat fresh or as preserves. A friend called it the "snack bar." He always stopped for a snack before letting us know he had arrived.

There is a cemetery to the right of the house as one faces it at the front. Both slaves and, later, freed people are buried there, as well as members of the Gaither family. The son of a former slave came each Mothers Day for many years, after we moved there, to put flowers on his mother's grave. I understand she was the plantation cook and weighed nearly four hundred pounds. The son's name was Charley Gaither and his mother's grave was near the left edge of the cemetery. It has a tombstone with her name on it.

An old barn stood near the big pond. This building was struck by lightning and burned in recent years.

I am about to forget another bit of history. It was told to my husband as the truth. It seems that the plantation once changed hands because the owner lost it in a poker game!

Another interesting fact regarding the Gaither Plantation is that two movies have been shot there. The first was *A Stroke of Genius*, a movie about golfer Bobby Jones made in 2003. The second was *Madea's Family Reunion*, a film by Tyler Perry that was shot in 2005. While filming *Madea's Family Reunion*, during one of the scenes taking place in the kitchen, the camera crews kept hearing someone making noises and walking around upstairs, causing them to stop filming twice and send someone upstairs to tell the person to stop making noise. Both times no one was there. Before the third take, the director politely asked the ghost to please stop making noise and allow them to get this shot. And the ghost obliged.

THE WINECOFF HOTEL FIRE

The Winecoff Hotel has an interesting connection to my own family's history. My grandparents, Lois Johnson and Hoy Hopkins, were married on June 21, 1946. They were extremely poor so the ladies from my grandmother's office all chipped in and paid for their honeymoon, which consisted of one night at the majestic Winecoff Hotel located at the corner of Peachtree Street and Ellis Street in downtown Atlanta, Georgia. This 195-room hotel was built in 1913, and it was the tallest building in Atlanta, with fifteen floors. The hotel was designed by renowned architect William Lee Stoddard and named for its owner, William Fleming Winecoff, who lived and tragically died there. The Winecoff was touted to be absolutely fireproof due to its all-brick exterior, though that was not the case. It did not have any of the current fireproofing in place. There were no fire escapes or sprinklers in the building, and the stairwell was in the center of the building with wooden doors. It was a virtual deathtrap.

At approximately 3:00 a.m. on the morning of December 7, 1946, a deadly fire broke out and spread throughout the hotel so fast that it was as if the entire hotel had been doused in accelerant. The hotel was filled to capacity, with over 280 guests, of which 119 perished. The fire was originally discovered by Alice Edmonds, a night maid who also acted as an elevator operator, food service provider and even a security guard. One of her nightly duties was to walk the floors from top to bottom checking rooms, making sure doors were locked and clearing halls of any debris that

The Winecoff Hotel exterior looks much like it did on the fateful night of the fire. The exterior was left unchanged due to the all-brick exterior. *Photo by Denise Roffe.*

could impede traffic in case of a fire. Edmonds had finished her nightly patrol of the floors less than an hour before she noticed the smoke of the fire that was, by most accounts, believed to have been started on the third floor. Although the cause of the fire was never officially determined, the original theory was that a cigarette was dropped on a rollaway mattress in the hallway of the third floor, thus causing an accidental fire. However, this theory was dismissed by most, and an arson investigation pointed to an intentional fire. There are strong theories, as well as evidence, that point to arson.

According to Allen B. Goodwin and Sam Heys, authors of *The Winecoff Fire: The Untold Story of America's Deadliest Fire*, the most likely scenario consists of an illegal poker game between known professional gamblers that was taking place in room 330. A man by the name of Roy "Candy" McCollough, who was a dangerous and violent criminal with a history of arson, barged in on the game with two other armed men and robbed the players. McCollough is said to have previously burned down a prison camp where he had been incarcerated just to murder one man who had ratted out a fellow inmate, thus sending him to the electric chair. Ray Maddox, one of McCollough's fellow gang members, claimed that McCollough recognized one of the gamblers as being someone who had turned him in years before on another incident, and he was furious and wanted to get even. Maddox said that he tried to stop McCollough from burning down the Winecoff but was unsuccessful, and McCollough was never convicted of the arson. However, McCollough died in prison in 1964 while serving a life sentence for an unrelated murder. He never admitted to starting the fire.

One of the hotel guests was twenty-eight-year-old bus driver Bill Bryson, who stayed in the hotel regularly due to the fact that the company he drove a bus for, Smoky Mountain Trailways, had room 928 at the Winecoff permanently rented out for its drivers to take mandatory rests between driving shifts. Ironically, Bryson had an immense fear of fire due to what he felt was a generational curse on his family. He claimed that every generation of his family had experienced a destructive fire, including his parents, whose home had burned a few years before. Bryson previously told his wife, Vera, of a premonition that he'd had indicating that he would die at the age of twenty-eight in a fire.

On that deadly morning, the flames were so hot and the smoke so thick that Bryson realized the fire was all consuming and there was no escape. He had no other choice but to climb on the window ledge and make the fateful leap to the Mortgage Guarantee Building, only ten feet away. But like many others who attempted and failed, he did not make it and fell nine stories to his death. Bill was on the back side of the building and above the eighth floor, where the majority of the people who died were. There were no fire escapes and the firemen's ladders only reached to the seventh floor. Many of the trapped guests made makeshift ropes by tying sheets together and trying to hang on, but the fire was so hot that it burned many of the sheets, causing them to break. On the ground, firemen were trying to catch people with nets who were falling and jumping, but the nets were not strong enough for the force of the falls and many of the nets ripped on impact.

The alley between the Winecoff and the Mortgage Guarantee Building was filled with bodies of jumpers and of those who had slipped. In fact,

The Winecoff is on the left, and the Mortgage Guarantee Building is on the right. The proximity of ten feet gave a false sense of security to dozens of people who thought they could jump to safety. Instead they fell to their deaths in the alley below. *Photo by Reese Christian.*

This alley between the Winecoff and the Mortgage Guarantee Building was littered with mangled bodies of the dead that piled up and ultimately saved some of the later jumpers. *Photo by Reese Christian.*

the broken bodies of the dead actually cushioned the falls of a few late jumpers who survived. The fire took the lives of 119 men, women and children who either died of smoke and gas inhalation, jumped or fell to their deaths or were burned by the fifteen-hundred-degree fire. Death became the new resident at the Winecoff on that morning, and today it lingers in the memory and haunting that abound on its premises. Though the Winecoff's interior was destroyed, the exterior stood strong with very little damage.

The Winecoff fire was the deadliest hotel fire in U.S. history, and it prompted many changes in building codes as we know them today. The Winecoff Hotel closed, and the building was bought and sold numerous times. It reopened as a hotel and later an elderly housing facility before closing in 1981 and remaining defunct for more than twenty-five years. In 2007, the shell of the building formerly known as the Winecoff was renovated into an elite hotel known as the Ellis Hotel. It was during the

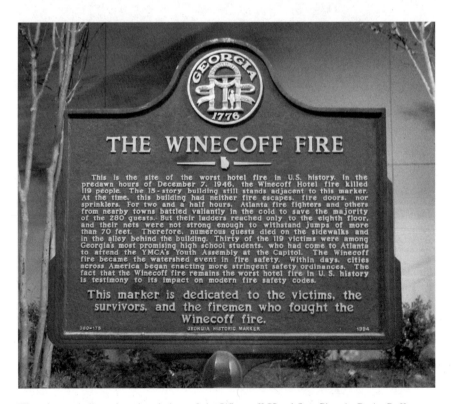

The plaque dedicated to the victims of the Winecoff Hotel fire. *Photo by Denise Roffe.*

renovation that many of the workers reported strange happenings. Some of the activity reported begins with a makeshift elevator that seemingly had a mind of its own and would travel the floors with no living passengers to ride or guide it. Many of the workers' tools would be lost, only to be found several floors away, often up on the higher floors. Also, there was a common report of the sound of children running and playing in the halls of the upper floors when nobody was there.

Today, several of the staff members have received calls at the front desk from unoccupied rooms with nobody on the other end of the phone. They have heard knocking on doors when no one is present. They have had guests complain of the noise in the halls on the upper floors, usually floors fourteen through sixteen, when there are no people in the halls to make the noise. They have also had repeated reports of the smell of smoke, only to find no fire.

The four-star Ellis Hotel is trying desperately to escape its legacy and cater to the elite, and the renovated hotel is very upscale indeed—just like the Winecoff was. If you are looking to spend the night in an upscale and quite haunted hotel, I suggest the Ellis. Why not have all of the perks of a four-star hotel while experiencing the ghosts of a historic haunt?

OAKLAND CEMETERY

A stroll through this botanical cemetery garden is meant to recharge the soul. The outdoor museum known as Oakland Cemetery is one of awe and reverence. Its beauty lies within its magnificent mausoleums, memorials and monuments, as well as its intricate grounds. Oakland cemetery is also a city park, and it is quite commonplace to see picnics, joggers, festivals and even weddings inside this eighty-eight-acre haven of the dead. Thousands of people visit the cemetery yearly for reasons ranging from the curious to the macabre, and there are approximately seventy thousand people buried there today.

Once known as City Cemetery, the burial ground originated in 1850 on six acres of land just southeast of the newly bustling city of Atlanta and was meant as a beautiful escape. City folk would visit their deceased loved ones in the graveyard garden while picnicking and consorting with the living. By 1872, the name was changed to Oakland in honor of the many majestic oak trees that adorned the location.

Many of Atlanta's original settlers were buried in this new cemetery, including Martha Lumpkin Compton, who was the daughter of Governor Wilson Lumpkin. Atlanta had briefly been named for Martha a few years earlier, but the general populous believed that Marthasville was too long and the name was changed to Atlanta.

The first person to be buried in Oakland Cemetery was Dr. James Nissan, who had a strange request upon his death. He asked the town

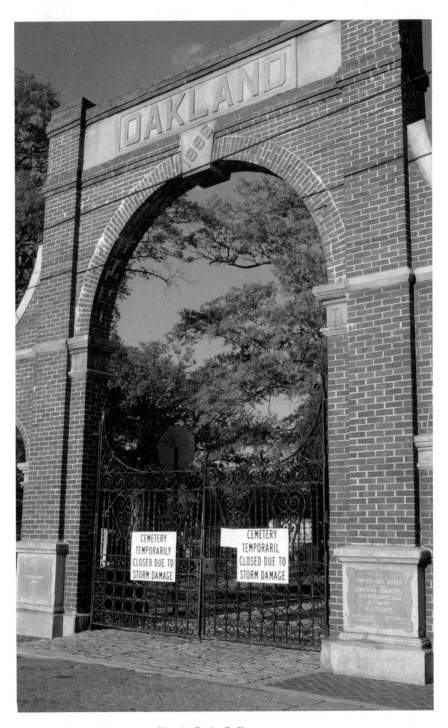

Oakland Cemetery entrance. *Photo by Denise Roffe.*

doctor to slit his throat, cutting the jugular vein, just prior to burial in order to ensure his death. The doctor obliged because at that time there was a common fear of being buried alive. Due to this mass fear, several of the graves had bells and alarms that were used to connect to the deceased so that they could ring the bell if they awoke. This is where the term "graveyard shift" stems from. During those times of plagues and war, people would often be mistaken for dead as stethoscopes were not yet widely used. So when they were buried, bells above ground were attached to a string that would lead down and be tied to the wrist of the departed. If they awoke, they could ring the bell and the attendant who was working the nightly "graveyard shift" could dig them out.

An interesting mausoleum erected in the original six-acre cemetery was that of Jasper Newton Smith. Jack, as he preferred to be called, had a life-size carving of himself made long before he died, and his unique mausoleum has him sitting and overlooking the rest of the cemetery. Jack had a phobia of ties due to his almost being accidentally strangled as a child, so he never wore them. When he had his carving done, the artist included a tie, which Jack was vehemently against, and Jack would not pay the artist until the tie was removed. Obligingly, the artist carved it away. Today, Jack is lovingly referred to as "the mayor of Oakland" by the current caretakers because of the stately watch he keeps over the cemetery. There is a rumor that one worker peeked into the crypt and saw a tie on Jack's neck!

A little over a decade later, the peacefulness of this soul resort was ransacked when the Civil War was at its height. A farmhouse stood on the property that was owned by James Williams, who would later become mayor of Atlanta. Bell Tower now stands on this land. From this farmhouse, General John B. Hood of the Confederate army conducted his troops in the Battle of Atlanta in 1864. Then, with the loss of thousands of Confederate soldiers' lives, the city bought several more acres to add to the cemetery in order to bury the dead. Thus a new section was born, respectfully referred to as the Confederate section. There are nearly seven thousand Confederate soldiers buried in Oakland Cemetery, and oddly enough there were approximately three hundred Union soldiers buried there too. Due to community concern and outrage, most of them were moved to other graveyards, but sixteen still remain in marked graves.

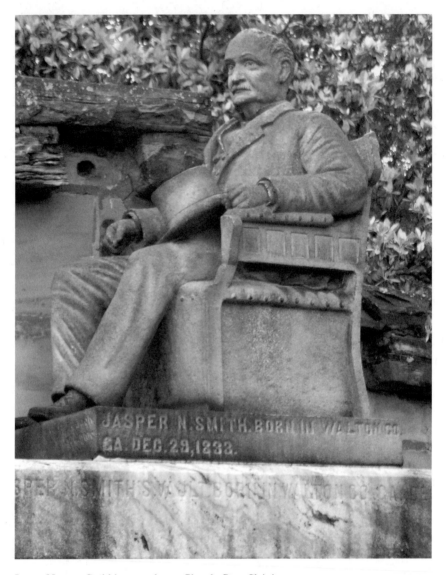

Jasper Newton Smith's mausoleum. *Photo by Reese Christian.*

The section was honored by a large sixty-five-foot-tall monument called the Confederate Obelisk that was made of Stone Mountain granite, and for years this was the tallest structure in Atlanta. There is also a second monument—one of the most majestic statues at Oakland—known as the Lion of the Confederacy, which guards a field of unknown soldiers in unmarked graves.

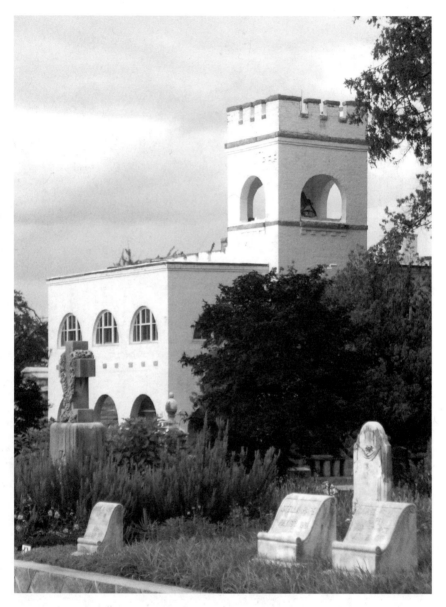

The Bell Tower. *Photo by Reese Christian.*

The Confederate section is also home to three Confederate generals: John B. Gordon, Clement A. Evans and William Wright. It is said that each year at twilight on November 14, the date that General Sherman and his army vacated Atlanta to head south toward Macon and Savannah, a

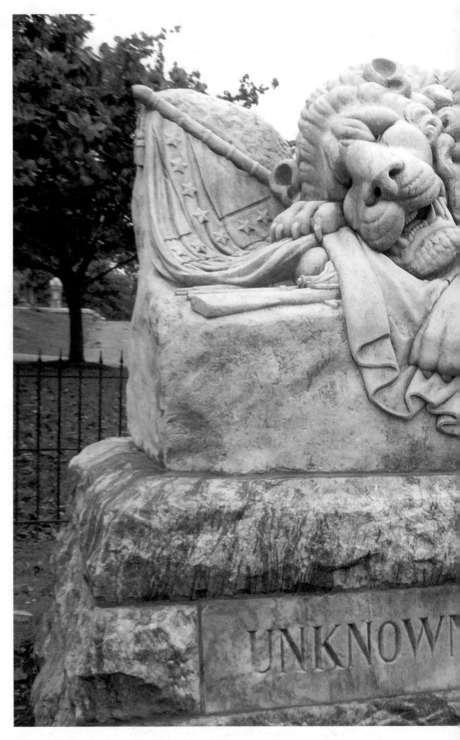

The Lion of the Confederacy. *Photo by Reese Christian.*

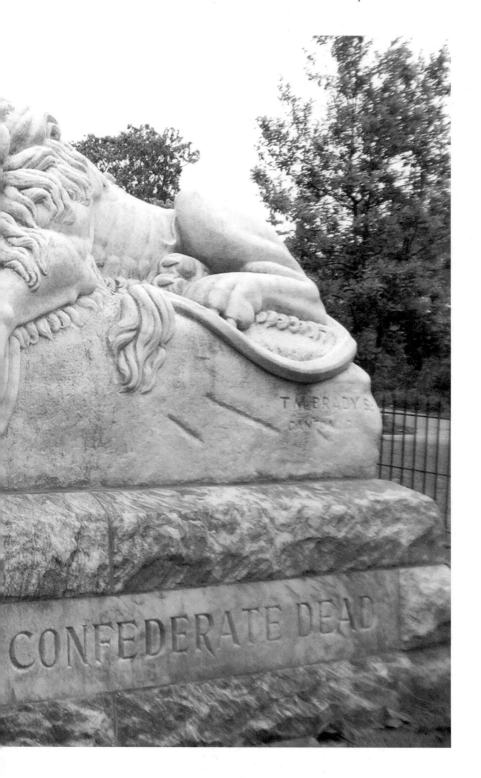

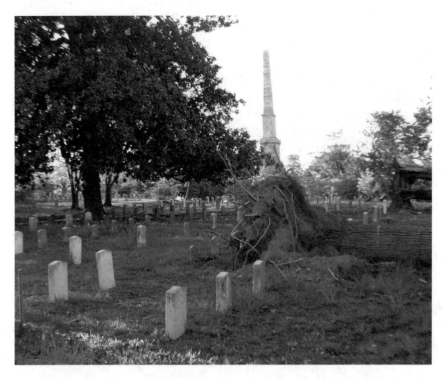

A small section of the more than seven thousand Confederate soldiers' burials, with the Confederate Obelisk in the background. The tornado severely damaged this portion of the cemetery, as seen here. *Photo by Reese Christian.*

"roll call of the dead" can be faintly heard in a ghostly voice, calling out the names of the dead who reside in the Confederate section of Oakland Cemetery. It has also been suggested that the "roll call of the dead" takes place on the date of the end of the Civil War, April 26, which also happens to be the Confederate Memorial Day. I personally have not yet attempted to witness this event, but suffice it to say that I will.

Contrary to popular belief, the poor and indigent were also buried in this cemetery in a section called Potter's Field. This seven-and-a-half-acre section holds approximately 7,575 burials, though its capacity was filled at 5,700. These were the folks who could not afford a burial, and there are very few headstones or markers for their graves. Since this is not a private cemetery, but is owned by the city, I believe it gives a more appropriate portrait of the people of Atlanta from all socioeconomic backgrounds.

This is a very small section of potter's field, approximately one-eighth of the total area of over seventy-five hundred unmarked indigent graves. *Photo by Reese Christian.*

Adjoining Potter's Field is the section known as the African American grounds. This section also represents the plight of the African American people in Atlanta's history. It has few grave markers due to the fact that most of the original markers were made of degradable properties, such as wood. Most of those buried here were slaves, and the only property they ever called their own was their final resting plot in Oakland Cemetery. However, not all of them were slaves or indigent. Some of them were outstanding overachievers, such as the founder of Morris Brown College, Bishop Wesley John Gaines; a key figure in establishing Spelman College, Reverend Frank Quarles; a community activist and founder of Atlanta's first African American orphanage, Carrie Steele Logan; and a successful realtor and educator who is buried in the only mausoleum in that section, Antoine Graves. Together with Potter's Field, the entire area holds more than seventeen thousand interments.

Another key African American buried in Oakland Cemetery is Atlanta's first African American mayor, Maynard Jackson. He is situated

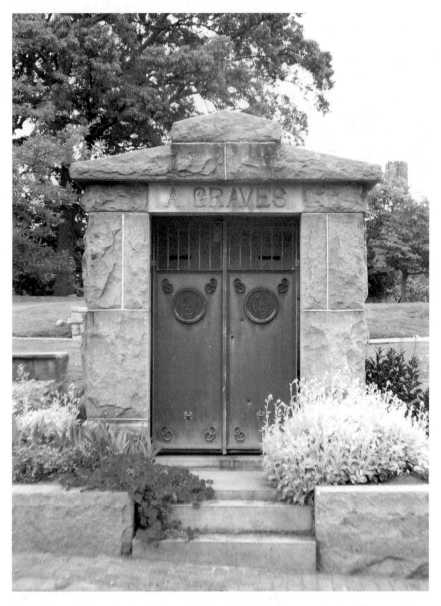

The only mausoleum in the African American section belongs to Antoine Graves, shown here. *Photo by Reese Christian.*

in a lone grave overlooking his beloved, modern city of Atlanta. His wife, Valerie Jackson, claims that when Maynard died she was looking for his spiritual guidance in finding his final resting place. She believes that she was spiritually led by Maynard to a monument in Oakland Cemetery because many years earlier, when Valerie was pregnant with their first child, Maynard told her, "This is our love child!" and the child was born on Valentine's Day. On her journey to find Maynard's burial ground, she was led to a monument that read, "ALL I ASK OF YOU IS FOREVER TO REMEMBER ME AS LOVING YOU," and the name on the stone read Valentine; the birth date on the stone was also Valentine's Day. It was at that moment that Valerie received her spiritual confirmation that Maynard wanted to be buried in the oldest, largest cemetery in the city of Atlanta, Georgia.

In 1860, the Hebrew Benevolent Society purchased burial plots in the original six acres of the Oakland Cemetery. Over the years, the Jewish sect in Atlanta bought several more plots, and now there is an entire section referred to as the New Jewish Burial Grounds. These gravesites are remarkable in that they are so tightly buried that there are no walkways in between them so as to maximize space. It is also interesting to note that Jewish customs usually command an underground burial, so the fact that there are seven mausoleums in the Jewish temple section is quite rare. A few of the more prestigious Jewish occupants are: Morris and Emanuel Rich, who founded Rich's Department Stores; Jacob Elsas, who founded Fulton Bad and Cotton Mill; and Joseph Jacobs, who owned the drugstore where Coca-Cola was first served.

The southeastern corner, known as Roger's Hill, is relatively obscure in terms of fame. However, I recently met a security guard by the name of Richard Curry who was kind enough to share his story with me. Mr. Curry is the night guard for Oakland Cemetery, and one night, upon doing his nightly rounds, he saw a dark, shadowy figure standing approximately twenty feet in front of him in the section known as Roger's Hill. He began to chase this apparition, fearing it was a person. It looked as if it turned to run and then it disappeared into nothing. Mr. Curry is not an easily frightened man, standing approximately six feet tall, and he is also not superstitious, but he claims that the incident was the scariest he'd ever encountered. At least it was until the night of the tornado.

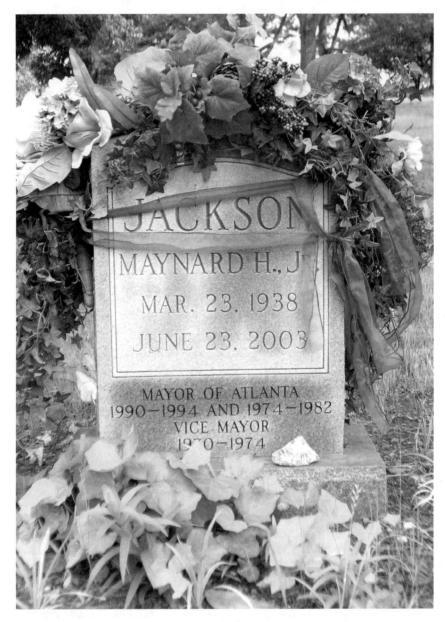

The prestigious grave site for the city's first African American mayor, Maynard Jackson. *Photo by Reese Christian.*

Security guard Richard Curry encountered an apparition at this corner on Roger's Hill in Oakland Cemetery. He also was the only staff member present on the night of the devastating tornado. *Photo by Reese Christian.*

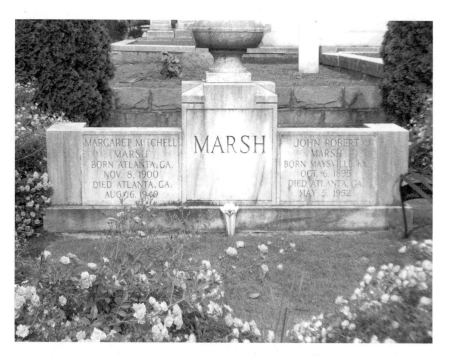

Margaret Mitchell's grave site. *Photo by Reese Christian.*

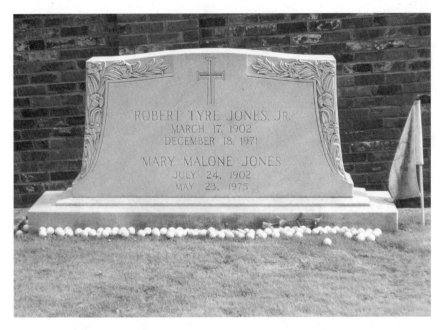

Bobby Jones's grave site. Notice the many golf balls left in homage to the legendary golfer. *Photo by Reese Christian.*

On March 14, 2008, Richard Curry was the only staff member on duty when a devastating tornado ripped through Oakland Cemetery causing millions of dollars in damage. Mr. Curry would normally have been out in the graveyard doing his rounds, but something faint told him to go into the Bell Tower building, and he did. Within moments the tornado charged through the cemetery, literally skipping over the building he was in and sparing his life while lifting hundred-year-old trees through the asphalt and hurling them across the graves. Were the tenants of Oakland attempting to save Mr. Curry that night? He believes so, and so do I.

Oakland Cemetery is Atlanta's oldest permanent landmark, and in 1976 it was placed on the National Register of Historic Places. It is the final resting place of many famous people, including Margaret Mitchell, Bobby Jones, six Georgia governors, twenty-six Atlanta mayors and so many more. It holds thirty thousand monuments, and many of them were severely damaged by the tornado. My hope is that the city of Atlanta, my home, can recover this historic prize from the clutches of devastation. I can only imagine how the residents are reacting these days.

SIX FLAGS OVER GEORGIA

In our quest to feel alive we tend to seek out death-defying activities that get our adrenaline pumping and our hearts racing, and our minds switch into pure instinct and survival mode. We thrive for the *fight or flight* within us to awaken the fear that will relieve our daily stress and anxiety. We need to feel alive.

While a few people are adrenaline junkies who utilize extreme sports to calm their cravings, the rest of us will suffice with a roller coaster ride at ridiculous speeds or a fifteen-story free fall to jolt us back into life. In acknowledgement of this need, the ever-accommodating amusement park Six Flags Over Georgia offers some of the most state-of-the-art attractions that are sure to make you face your fears and experience ultimate exhilaration.

Angus Wynne founded the original Six Flags Over Texas in 1961, followed by opening sister parks in Georgia and St. Louis, respectively. He sold Six Flags to Penn Central Railroad Corporation in 1965, after having already begun construction on his second park, and it has changed ownership numerous times since then. Wynne had a brilliant concept in that he wanted to bring a large park to regional areas where they could be easily accessed, and he wanted to generate not only a park of thrilling rides, but also one separated into themes. The six flags represented the six national flags that had flown over Texas throughout its rich history. In 1967, when the first sister company, Six Flags Over Georgia, was opened,

The entrance to Six Flags Over Georgia. *Photo courtesy of the Tim Hollis Collection.*

it utilized the six flags to represent six themes that had predominated the Deep South's heritage and culture. These original six themes were: the Old South Confederacy; the state of Georgia; colonial Britain; colonial Spain; French influences; and of course, the patriotic influences of America.

Today, Six Flags has twenty-one theme parks throughout North America, including Mexico and Canada. During its evolution, Six Flags over Georgia has changed and updated themes, added sections and characters and kept a constant watch on the contemporary desire for bigger and better thrills. The park has arguably some of the best roller coasters in the nation, totaling ten at the present time, and it is a thrill seekers haven. The only original ride that remains today is the Dahlonega Mine Train. This has to be my very favorite ride in all of Six Flags, and has been since I was old enough to ride it. The ride looks pretty creepy and may appear to have a ghost or two, but unfortunately it does not. However, this is a must-ride on your next visit to Georgia's best theme park.

Speaking of haunting, there is in fact a well-known ghost story that locals and staff members alike will share and many have even experienced. The story states that in the parking lot there is an area at the farthest corner away from the park where a gas station is nestled. In and around that gas

station, the spirit of a young girl is seen wandering and crying for her mommy. It is believed that she was lost from her family and drowned in the Chattahoochee River just behind it, and now her soul lingers, cursed to spend eternity searching for her parents to lead them to her body. Many people have reported seeing this lost child and being led into the woods toward the river. Once they are deep within the wooded area the girl vanishes, leaving them bewildered and lost themselves.

Could this be an urban legend? I suppose it's possible, but how would that explain the fact that very similar stories are shared by people who have no connection with one another? And the story has been repeatedly reported for decades.

The theatre located inside of Six Flags is called the Crystal Pistol and it has an antebellum architectural structure. This theatre is fully enclosed and has been around since the park opened offering live shows and musicals to adoring audience members for decades. And, as most theatres are, this one is haunted. Apparently, a young man by the name of Joe (last name unknown) was a performer who was on his way to his opening performance at the Crystal Pistol when he was killed in a car crash in 1967. Since his death, many performers and staff members have claimed to see a ghostly apparition of a man standing in the balcony watching the performances. They also report hearing a man singing backstage after the theatre has closed, but there is nobody backstage when they investigate. Finally, they have complained that their props keep mysteriously moving about the theatre on their own, and even onto the train tracks that are just outside of it. It appears that Joe is a bit of a trickster, and he is still performing at the Crystal Pistol awaiting his moment of fame and glory.

A beautiful, historic landmark that resides in Six Flags is the Riverview Carousel. It was built in 1908 and is celebrating its centennial birthday this year. The carousel is Six Flags' contribution to the National Register of Historic Places, and it was built by the Philadelphia Toboggan Company, whose signature contributions to the amusement park industry were roller coasters and five-row, hand-carved, regal horse carousels with adornments of angels and gold. This beautiful carousel has seventy horses and was originally built for Riverview Park in Chicago, Illinois. That park was opened from 1908 to 1967, and when it closed the carousel went into storage until 1972, when Six Flags Over

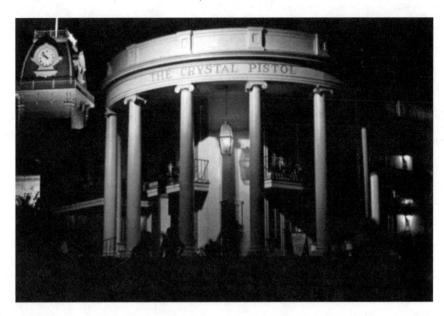

This is the haunted Crystal Pistol Theater located inside the park. *Photo courtesy of the Tim Hollis Collection.*

Georgia purchased it and had it meticulously restored with all horses intact except one. Today the attraction looks more like a museum piece than a ride, and I assume it will be retired as such in the coming years. It is suspended from a twenty-four-foot old ship's mast center pole, and its housing is made from the former Riverview Park structure. Many famous icons throughout history have ridden on this magnificent piece of art, including President Harding, William Randolph Hearst and Al Capone, to name a few.

One of the horses on the ride is often accused of being haunted. This black horse does exude a morbid feel with its dark demeanor, and it's possible that it could be connected with a ghost or two from its colorful past. Although I could not confirm this, I was told of a young boy who fell from the carousel and died from a head injury many years ago when the carousel was still located in Chicago. On occasion, the spirit of a young boy is seen riding this dark horse of death. He is also associated with other supernatural occurrences happening at this ride, including the many rocking chairs that line the ride beginning to rock on their own when there are no winds or other factors to blame, flickering lights, music turning on

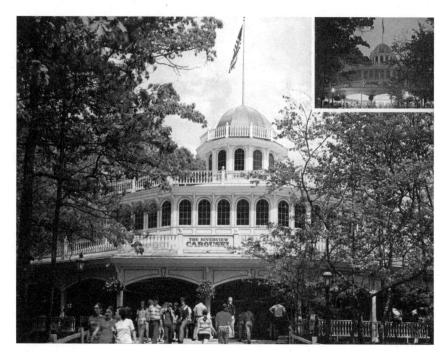

The Riverview Carousel. *Photo courtesy of the Tim Hollis Collection*

and off and the ride beginning to move on its own for no apparent reason. Does he not realize he has passed? I feel sorrow for this boy who may be stuck in the netherworld, and if you happen upon him while riding his favorite dark horse, please show respect and make him feel comfortable. Otherwise, you may experience some of his ghostly antics.

Another favorite family ride at Six Flags Over Georgia is known as the Monster Plantation. It was originally built as the Tales of the Okefenokee Swamp ride in 1967, with characters based on the *Uncle Remus* tales. However, in 1981 the ride was redesigned to a more politically correct version entitled the Monster Plantation. This is also a ride that some believe to have ghosts lurking about. An old story that I've heard repeated several times states that a child is often heard crying in the marsh area of the ride, but there is no one there. It is rumored that a child jumped out of the ride, never to be found again. I'm sorry to say that this is strictly urban legend. There is no truth to the story of a child being lost on this ride and never being found, but that begs the question: who is the child

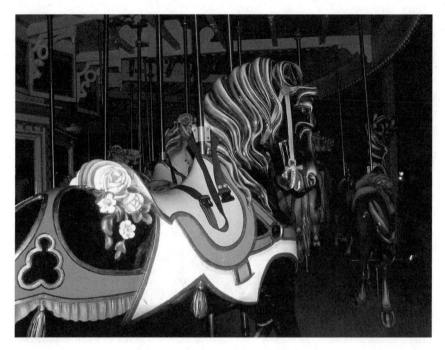

The haunted dark horse on the Riverview Carousel at Six Flags Over Georgia. *Photo by Denise Roffe.*

that is heard crying by so many different people when no one is there? Well folks, I guess you'll just have to go and see for yourselves.

It is also interesting to note that several of the park employees seem to think that the ladies' public restroom that is nearest to the Monster Plantation is also haunted. The water faucets come on and turn off by themselves, and the toilets flush randomly. One employee has seen an apparition of a Native American woman in one of the stalls. The land is located next to the Chattahoochee River, which was a common area for Cherokee and Creek Indians to have lived, so it is feasible to think that this woman once occupied that land and possibly died there.

Another ride that is absolutely haunted is the Batman suspended roller coaster. In 2002, a park employee, Samuel Guyton, entered a restricted area while the roller coaster was active. A girl's dangling legs slammed into his head, and he died later at the hospital. Since his death, there have been many reports of cold spots, electric malfunctions, ghostly sightings, whispers and even electromagnetic spikes. It seems that in the enclosed

The exterior of the Monster Plantation ride. *Photo courtesy of the Tim Hollis Collection.*

The front of the former Okefenokee Swamp ride that was converted to the Monster Plantation. *Photo courtesy of the Tim Hollis Collection.*

long line area is where most of the activity takes place, and even many of the employees are convinced that he is still there, haunting the ride and its patrons.

Six Flags Over Georgia is by far one of the best theme parks I have ever encountered, and the fact that it has a few ghosts only serves to make it that much more entertaining. The themes within the park are very intriguing, and I only hope that they do not get too far away from their original purpose of telling the story of the Deep South in Georgia.

STONE MOUNTAIN

S tone Mountain, a huge exposed dome of granite rock, is located just east of Atlanta. It is often thought that Stone Mountain is the largest monadnock in existence, but this is not the case. El Capitan in Yosemite is actually four times larger. However, the monolith known affectionately as Stone Mountain has a fantastically haunting history, and I'm sure that much of the paranormal activity can be attributed to the fact that it's made of granite. Granite is known to enhance, attract and even cause paranormal activity due to its naturally high electromagnetic fields (EMF). These fields will affect the brain's activity and cause hallucinations, delusions and even paranoia, which is why when high EMF readings are found by paranormal investigators, they will usually debunk the haunting for the most part. On the flip side, the elevated electromagnetic fields may also be exploited by ghostly visitors who need to borrow the energy in order to manifest themselves and their ghostly deeds. So, when there are other signs of high paranormal activity outside of the human factor, paranormal investigators will attribute the haunting to the high EMF surrounding the place. Stone Mountain has extremely high electromagnetic fields.

Stone Mountain has been home to human beings dating back to the Archaic Indians who would have lived there approximately eight thousand to ten thousand years ago. There were rock walls atop the mountain that date back to one of these archaic tribes, referred to as the Mound Builders.

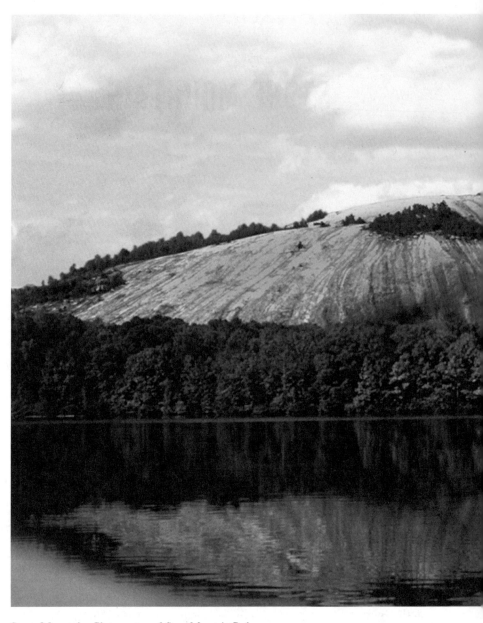

Stone Mountain. *Photo courtesy of Stone Mountain Park.*

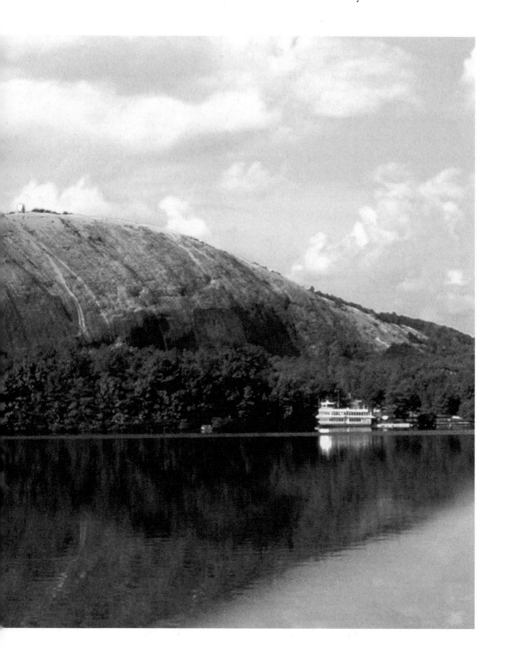

These walls have since been dismantled and removed by people taking the rocks illegally. Stone Mountain has been hailed by many native nations as a divine place, believed to have mystical powers. This was a place where one could consort with the gods.

In 1567, Spanish explorer Juan Pardo visited the mountain in search of the Mound Builder civilization, which another explorer had discovered years before, but the Mound Builders had been replaced by the Creek Indians. The Creeks named their home Lone Mountain, while Juan Pardo gave the mountain another name, Crystal Mountain. By the late 1700s, the settlers were moving west, and they would use the mountain, known to them as Rock Mountain or Rock Fort Mountain, as a landmark.

In 1821, the Creek Indians ceded the land to the State of Georgia, which then sold off the land in a lottery to six winners. Stone Mountain changed hands a few times, with both private owners and corporate owners, until 1958, when the State of Georgia reacquired it. By 1822, Stone Mountain was absorbed into the newly formed Dekalb County, but the name officially became Stone Mountain in 1847. Earlier in 1846 Stone Mountain was hosting an agricultural fair that was fought for and won by Atlanta in 1850. At this point, Stone Mountain had become a vibrant town with hotels, plantations, small villages, a post office and even a lookout tower at the top of the mountain for people who were riding the train from Augusta through Stone Mountain. The train would stop for an overnight stay in this bustling new city, and it thrived indeed.

In Stone Mountain Village, which comprised a collection of stores, hotels and more, there was an inn that is known today as the Village Inn Bed and Breakfast. This inn served originally as a hotel to the many people who were coming to see the vast mountain. However, in 1864, during the Civil War, the inn was utilized as a hospital for Confederate soldiers and was spared by the Union troops. In 1868, it was bought by Reverend Jacob Stillwell to house his large family that consisted of himself, his wife and nine children. Many years later the inn was bought and sold many times over, and of course it reverted back to being an inn. In 1995, the new innkeepers (they have asked not to be identified by name and they are not the current owners) were renovating the house when they began noticing all kinds of strange activities taking place, such as finding things moved from where they had left them or things that had

Stone Mountain Village Inn. *Photo by Denise Roffe.*

been propped against the wall falling over. Several times the innkeepers felt eyes watching them, only to turn around and find no one there. The following is an actual report on paranormal activity that I was given by the former innkeepers.

The Village Inn Paranormal Activity Report

THE FOLLOWING ARE DOCUMENTED CASES

During Renovation: (1995)
Boards and equipment would move from room to room. At times, they would hear the voice of an old African American man singing a hymn. Thinking that a homeless man was in the area and had wondered in, they would go look for him. No one was ever there.

During renovations they found boards with names written on them from when it was a hospital. The names were of soldiers who would write on the walls above their beds. After the boards with Civil War soldiers' names were found, things began to move about the Inn more often.

Scarlett's Room:
Guests have awakened to the smell of heavy perfume. One couple asked to be moved from the room when the wardrobe door opened inexplicably in the middle of the night. Another guest witnessed a hair brush float in mid air then suddenly drop to the floor. Whatever is in Scarlett's room seems to be female.

Angel Room:
Guests in the angel room have seen the face of a young man in the bedside mirror. Some say the apparition is speaking, although nothing is heard. His image fades as he tries to speak.

Rhett's Room:
Rhett's Room is where the boards with Civil War soldiers' names carved in wood were found. The rocking chair rocks on its own. This is also the room where the second owner of the inn was sleeping when she was awakened by the sound of the man singing an old southern hymn. [This same phenomenon happened during the renovations with the later owners.] *She got dressed and walked out on the verandah, thinking the church must be having some kind of event, but she could no longer hear the man singing. When she walked back into the room, she heard him as though he was right beside her.*

The Yellow Room:
In this room hung a shadowbox containing a beautifully made antique dress for an infant. One couple was staying in the Yellow Room for a much-needed rest after losing their infant daughter. As they talked about their loss, the dress fell off the wall. Another guest staying in the Yellow Room was joined by an unseen presence. The presence sat down on the bed next to him.

The Blue Room:
While the 1995 innkeepers owned the inn, they employed a housekeeper. The housekeeper would never be in the room alone—not even to clean up after the previous night's guests. She said there was a presence in the room. On Halloween night, the owners received a phone call at

approximately 1:30 a.m. The guests in the room were complaining that there were wasps in the room. Upon arrival, the innkeepers walked into the room to investigate and discovered that the room was unseasonably cold. They could actually see their breath. There were in fact wasps in the room—in October. The guests were moved to a warm, wasp free, vacant room. Another night, guests in the Blue Room called saying that they were freezing. Again, when the innkeepers arrived, the room was so cold they could see their breath while the hallway and other rooms were not cold. At this time, the inn was not on separate heating/cooling systems.

A newlywed couple staying in the Blue Room reported that at 3:00 am, they were awakened by the door to the room flying open and banging against the wall.

Ballroom Suite:
The laughter of children and faint sounds of music are often heard in the Ballroom Suite. At times, there is a loud noise as though there is a party (when the room is empty) wafting down from the suite to other rooms.

As a previous owner was walking from their home next door, they looked up and saw a figure walk past the window in the third-floor bedroom (light was on and the figure was silhouetted). When they got to the inn, there was no one there. They went up to the third floor and found no one.

Common Rooms and Overall Haunting:
As a previous owner was coming down the stairs while preparing for a wedding, she saw a flash of light in front of her—an orb perhaps—and there was no source for the light. She reports that she had an overwhelming feeling that she was *NOT* supposed to look up at that exact moment. "The flash was weird, but the feeling even more weird."

Guests are reported to hear "Morse Code" sometimes.
Chains on the guest room doors rattle inexplicably.
Candles are knocked into bathtubs on their own.
Doors will open and close by themselves.

Lights are known to turn themselves off and on.
Periodically, pipe smoke is smelled—without a source.

By 1864, the Civil War brought the Union troops to destroy Stone Mountain Village and tear up the railroad tracks. Many lives were lost in this tyrannical bloodshed, as well as homes and other material items. Stone Mountain's citizens had to rebuild, and they did. I should also note that Stone Mountain was quarried for its granite from the 1830s up until the 1970s, and this was a huge commercial enterprise.

A darker period in the history of Stone Mountain was when it became the home to the Ku Klux Klan (KKK) in November of 1915. William Simmons and several other men are all believed to have lynched a Jewish man named Leo Frank, who was wrongly convicted of murdering a young Caucasian girl by the name of Mary Phagan (Frank was pardoned in 1986). Simmons and his cohorts met atop the mountain two years later to "burn a cross" in celebration of the rebirth of the KKK. This group called itself the Knights of Mary Phagan, and that night the oath was administered by Nathan Bedford Forrest III, the grandson of the original imperial grand wizard, General Nathan B. Forrest. Samuel Venable, then the owner of Stone Mountain, witnessed the ceremony and granted the Klansmen the right to hold their future meetings there atop the mountain via an easement. Later, when the state took ownership of the property, they had to condemn it in order to release the easement and revoke the Klan's permanent rights to the property. It is interesting to note that Reverend Martin Luther King Jr. included Stone Mountain in his "I have a dream" speech.

Although it was not their idea, the Klansmen were immensely influential in the carving that would go on the face of the mountain. Stone Mountain boasts the Confederate Memorial Carving, which is the largest low-relief sculpture in the world. It depicts three Confederate Civil War heroes: President Jefferson Davis and Generals Robert E. Lee and Thomas J. Stonewall Jackson. The carving began in 1916, but due to surmountable obstacles it wasn't completed until 1970. At least two men fell and died while working on this magnificent sculpture, and some speculate that their ghosts linger on to protect the carving.

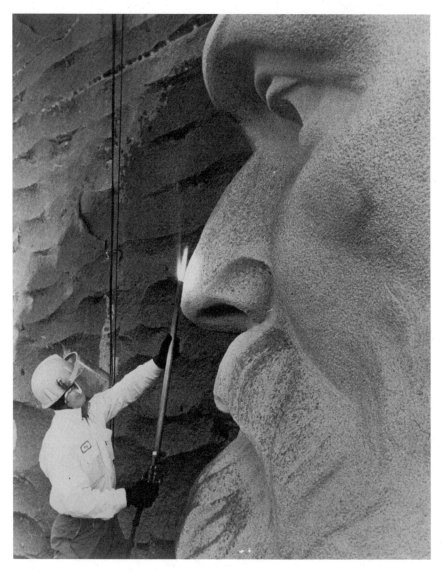

A man working on the Confederate Memorial carving. *Photo courtesy of Stone Mountain Park.*

In 1962, Stone Mountain Park opened with the Scenic Railroad followed by many other famous attractions including the Antebellum Plantation. The Antebellum Plantation consists of a small village inside the park where they have literally relocated more than a dozen structures of historic value. Several of these structures have resident ghosts who often make appearances to the staff and to the patrons as well. The

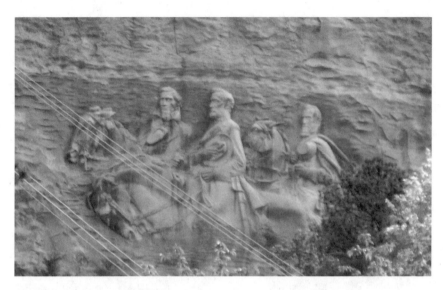

The Stone Mountain Confederate Memorial carving. *Photo by Reese Christian.*

most impressive mansion is the Dickey House, circa 1840, which is an astounding 6,250-square-foot plantation that overlooks a large field where Civil War reenactments take place. Through the years, many of the reenactors have reported seeing a lady in the windows of the Dickey House, only to find it empty.

The Thornton House, circa 1784, is the oldest restored house in the state of Georgia, and it seems to have the most ghostly sightings and interactions. Although there are no reports of the original owners experiencing the death of a young girl, the home was lived in for over 150 years by many families, and there are no records available on all of the previous tenants. However, the apparition of a preteen girl is often seen on the landing at the top of the stairs or on the stairs themselves, and she has frequently been known to pull the hair of teenage girls visiting the home. It is believed that she doesn't like the dark because staff members have seen her at closing time when they are turning out lights, and she doesn't appear to be happy. Another staff member witnessed a mother and her little girl of approximately five years of age climbing the stairs when the little girl stopped and said, "OK." She then went back down the stairs. When her mother asked her if she wanted to come up to see the girl's room, the little girl replied, "The lady on the stairs told me not to."

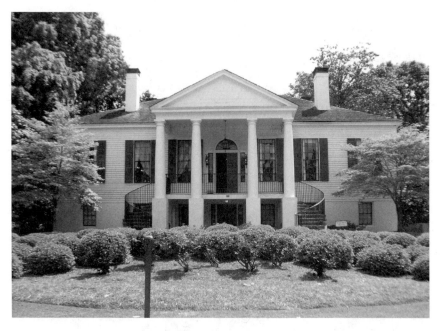

The Dickey House is the most impressive of the plantation's attractions, and it seems to have a ghost of a lady who never leaves the home. *Photo by Reese Christian.*

The on-site historian, Cindy Horton, also had an eerie encounter with a bright orb that was visual to the naked eye. It was floating at the top of the stairs as if to call her up. Once she arrived at the top of the stairs, she found a window to be broken and in need of repair in what would have been the daughter's room of the family that had once owned the home. Horton feels that the girl was trying to tell her of the broken window so that the room would not be damaged by weather. The last paranormal event that seems to happen regularly at the Thornton House is that candles blow out by themselves simultaneously and on a regular basis all throughout the home when there are no breezes to blame.

The Coach House, which was rebuilt from the bricks of two historic coach houses, is also the location of an office. Several staff members have heard children playing and running around upstairs when they were downstairs in the building alone; and if they are downstairs, they hear the noises upstairs. A family, who appears to be dressed in attire from the early twentieth century, is also reported to be seen in the windows.

The top windows in the Dickey House are where the lady spirit is often seen. *Photo by Reese Christian.*

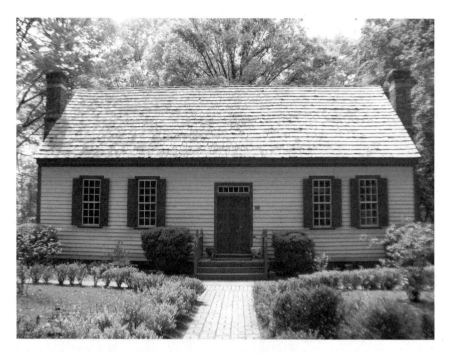

The Thornton House seems to have the most paranormal activity of all of the homes and buildings on the Antebellum Plantation in Stone Mountain Park. *Photo by Reese Christian.*

The barn, circa 1800, is found to be rather odd by staff members in that, despite of the fact that it is completely open with many areas for animals to enter, there is not one single animal ever found in the barn hiding, nesting or otherwise. The staff members feel that the barn must have a supernatural presence that the animals sense and wish to avoid. In the 1960s, an older male caretaker died in the farm area and for years his spirit was believed to have been seen in and around the barn.

The last area of the Antebellum Plantation that experiences ghostly phenomena is the Kingston House, circa 1845. There is a chair that moves about on its own. When the caretakers close the house at night, the chair will be in one spot, but when they open up on the next day, the chair is in a completely different place or it is turned over altogether.

Stone Mountain Park is loved and visited by many, and in 1996 it hosted several venues for the Summer Olympic Games. Although I have lived within a forty-five-minute drive of Stone Mountain my entire life,

These stairs in the Thornton House and the landing at the top are the locations of the most ghostly sightings. Notice the light anomaly at the top of the stairs? *Photo by Reese Christian.*

The Coach House is another building with numerous reports of ghostly activity. *Photo by Reese Christian.*

This historic barn seems to be completely void of life according to the staff members and caretakers of the Antebellum Plantation. *Photo by Reese Christian.*

The Kingston House is where poltergeist activity is reported in the form of furniture moving on its own. *Photo by Reese Christian.*

I've only visited it a handful of times. With every visit I felt different energies and spirits attempting to communicate, and usually they were just passing through and wanted to share a friendly "hello" with someone who could hear them.

The old Stone Mountain Cemetery at the end of Main Street dates back to the early 1800s. This cemetery is reported to be quite haunted, with all of the ghouls and goblins you'd expect, especially around the Confederate soldiers' graves. There is also a quite neglected cemetery that is located behind the Days Inn that is also reported to be haunted, most likely due to its Sleepy Hollow appearance. However, I suggest visiting other haunted, historic locations and allowing the tenants in these two grave sites to rest in peace.

KENNESAW NATIONAL
BATTLEFIELD

With the same historic residents as Stone Mountain, Kennesaw Mountain's original occupants were the archaic native tribes known as the Mound Builders. The Creek Indians were possibly descendents of the Mound Builders, or more likely they conquered them to become residents of Kennesaw Mountain. In 1755, the Creeks were aggressively overthrown by the Cherokee Indians, who often encroached on Creek territory and ultimately forced them into Alabama as they conquered land in Georgia. However, the Cherokees weren't the only enemy to steal land—as they would soon learn, the white man was just as culpable in this process.

The Cherokees utilized several areas of land on and around Kennesaw Mountain (pronounced "Gha-nee-saw" by the Cherokee) as burial grounds, and this would be a morbid foreshadowing of the carnage that would become the bloodiest battle in the Atlanta Campaign of the Civil War. Only decades before the war began, the Cherokees had been thwarted from their land by the U.S. government in an effort to plunder their resources, as well as the gold that was discovered in North Georgia, thus starting the gold rush.

For those Cherokees who lived on and around the Kennesaw Mountain, the forceful removal from their land caused massive suffering and death. The Cherokee people were forcibly removed and placed into forts, or more accurately concentration camps, that were inadequate for their

These signs are at the entrance areas of Kennesaw Mountain National Battlefield Park. *Photo by Reese Christian.*

Kennesaw Mountain with the battlefield in front. *Photo by Reese Christian.*

survival before beginning their journey to "Indian Territory," which is now known as Oklahoma. This forced pilgrimage is commonly referred to as the Trail of Tears. The Cherokees' actual words were *Nunna daul Tsuny*, which means "The Trail Where They Cried." The Cherokee people fought for their land and homes diligently, but they lost to the brute of the armed forces who physically removed them. Overall, an estimated four thousand Cherokees died from malnutrition, exposure and vast disease during their imprisonment and extraction. Some believe that the natives cursed the land that they were forced to leave, including Kennesaw, which still held the remains of their buried ancestors. Could they have placed a curse upon this land? Given the history and bloodshed that Kennesaw Mountain has seen, I don't doubt it.

Kennesaw National Battlefield now preserves the Civil War battleground where 5,350 soldiers died in the campaign from June 19, 1864, to July 2, 1864. There were three core battlefield areas: the valley that lies in front of Kennesaw Mountain (also known as Big Shanty), which is now in front of the visitors' center; Cheatham Hill (more commonly known as Dead Angle), which was the deadliest of the battles; and Pigeon Hill. The Union army, led by General Sherman, was 1,000 men, 254 guns and 35,000 horses strong, while the Confederate army, led by General Johnston, had only 63,000 men and 187 guns.

Throughout the war, Sherman outflanked Johnston time and again, until they reached the small chain of mountains that included Kennesaw. There Johnston had the advantage of higher ground, and Sherman had to take a different approach. Sherman's new, more direct style of constant barrage was meant to weaken the core of the Rebel brigade, and the attacks were unlike any they had ever encountered. Men were fighting in fields covered in bodies of the dead and wounded, and most often the Federal soldiers were slaughtered. The loss of life was astounding for both the Union and the Confederate soldiers, and though the Union soldiers had twice as many men, they suffered nearly three times as many casualties. Indubitably, the Union soldiers simply had more lives to give, and give they did. During the bloody battle of the Dead Angle, Confederate Colonel Marshall declared a mini cease fire so that the battling men could work in harmony to clear the grounds of the casualties. A vast majority of the dead who were killed in this particular

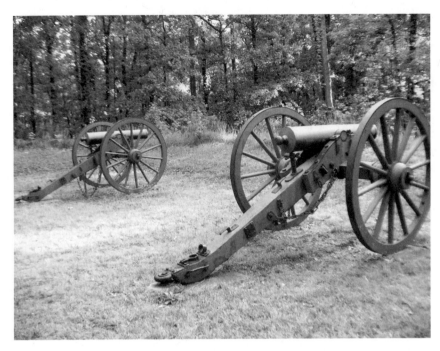

These were the types of cannons that were used during the Civil War. They were often camouflaged and hidden for surprise attacks. *Photo by Reese Christian.*

battle were Federal soldiers: approximately 1,000 died in less than two hours while only around 350 Rebels were killed. One moment they were savagely attacking one another and the next they were cooperating, side by side, in clearing the dead and rescuing the wounded. The conflict of emotions must have been mortifying, to say the least.

Ultimately, the Battle of Kennesaw Mountain was won by the Confederate corps, but as history goes, the war was won by the Federal army and the land ceded to the Union. In an effort to preserve the area as a national battlefield, Illinois bought a tract of land in 1899 near the Dead Angle to build a memorial to the nearly five hundred Illinois men who lost their lives in that one battle. The monument was finished in 1914 and was dedicated to the fallen soldiers.

The War Department took over management of the area in 1917 and expanded it to cover almost the twenty-nine hundred acres it envelopes today. In 1933, Kennesaw National Battlefield was transferred to the Department of the Interior as a unit of the National Park System, but by

For the Union soldiers who made it past the slaughter of the dug-in Rebel soldiers in the many trenches of the Dead Angle, they would fight out the rest of the battle on this battlefield at Cheatham Hill. There are miles of trenches, known as earthworks, preserved there today. *Photo by Reese Christian.*

the 1960s the park became threatened by the expansion in the modern era. The park took on a new life of not only being solely a historic battleground, but also becoming a highly visited recreational park where visitors and locals alike would picnic, jog and hike. There are currently over eighteen miles of interpretive walking trails, a trolley that will take you to the top of the mountain, an informative visitors' center and many historic monuments and sights to see.

One can only imagine the ghostly sightings and activity that would abound in a place of such massacre and carnage. One such sighting was to the astonishment of a father and his teenage son, who are both Civil War history buffs. As they were driving on the road in front of the battlefield, they both saw a Union army cavalry officer riding on horseback with saber in hand. He crossed the road directly in front of their car and disappeared into the battlefield.

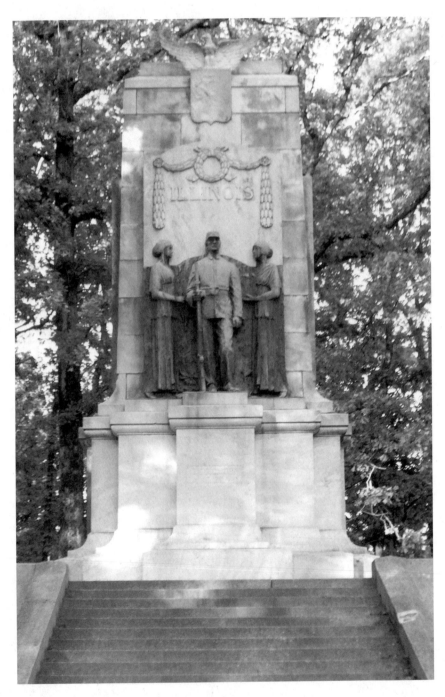

The Illinois Monument. *Photo by Reese Christian.*

This is an example of the sudden "fog" that appears from nowhere. The day was bright and sunny with no clouds in sight and then a sudden fog occurred on or near a battlefield. I was lucky enough to witness this and capture it in a photograph. *Photo by Reese Christian.*

Another common sighting occurs along the trail that leads to the Illinois monument. Apparitions of burned Union soldiers have been seen in the woods and near the monument. There was a large fire in the battle at Dead Angle, and many of the wounded Federal soldiers burned alive. It is believed that these are their ghosts at unrest.

Upon speaking with local residents and a few staff members, none of whom wished to be identified, the most common stories of ghosts are as follows: Some have reported seeing deer running toward them in the woods, and as the deer descend upon them, they vanish into thin air. Others have reported seeing apparitions of soldiers in all areas of the park walking around in a daze. Still others have experienced sudden fog, seemingly coming from nowhere, accompanied by the sounds of drums, marching, running footsteps, roll calls and screams, as well as the smells of blood and gunpowder. And let us not forget our Native American ancestors who are no longer resting at peace in their Indian burial grounds.

The sounds of native drumming and Indian calls, as well as the sightings of full-bodied apparitions of Cherokee tribal leaders in full costume, occur intermittently throughout the area. All of the people who have experienced these incidents firsthand are of different backgrounds and socioeconomic climates, and they all hold very true to their convictions.

Most of the park rangers and security guards are very tight-lipped and claim to have never experienced anything supernatural, but as most government conspiracies go, some of their stories change behind closed doors. A visit to Kennesaw Mountain Battlefield will have a profound impact on anyone, whether that impact is paranormal or simply human. To be in a place of such profound suffering, fear and death will affect the emotions of anyone. As a medium, it is an awe-inspiring experience to mingle with so many souls at once, and I would gladly go back time and again.

THE BARNSLEY GARDENS

A little town called Adairsville sits just an hour northwest of Atlanta, and its culture is deeply influenced by its former Native American tenants and later by the Civil War. Originally, Adairsville was part of the Cherokee territory that included New Echota and Calhoun, where the Cherokees formed their own structured government. Soon after forming their self-governing cities, they were forced out of their own land in the Trail of Tears of 1838. Upon removal of the Cherokees, many affluent Southern men moved into this area to explore its possibilities. The Western & Atlantic Railroad was brought up from Atlanta, and soon the town was bustling and experiencing fast growth and success. By 1854, the town was incorporated. However, in 1864 the Civil War's Atlanta Campaign came through with the Battle of Adairsville, which nearly destroyed the town. Fortunately, some of the buildings were spared and still stand today.

The entire town of Adairsville has been listed in the National Register of Historic Places since 1987, and one of the many town commodities is the Barnsley Gardens, originally known as Woodlands Manor. In 1805, Godfrey Barnsley was born in Derbyshire, England, to a working-class family. Barnsley left England at the age of eighteen with neither money nor education on his side, but he was a driven and determined young man. He began working in Savannah, Georgia, in a cotton factory, and within ten years he became one of the wealthiest cotton merchants in the South. Barnsley was truly a self-made man.

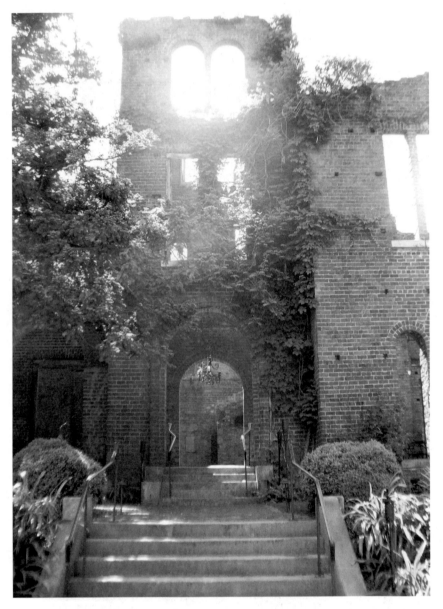

The entrance to Woodlands Manor ruins at Barnsley Gardens. *Photo by Reese Christian.*

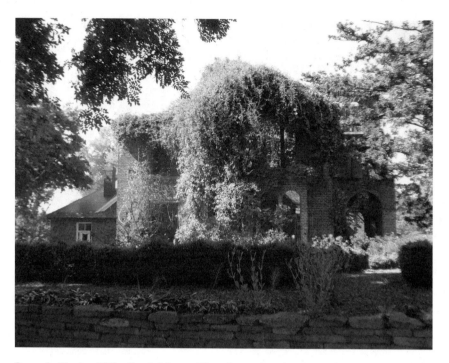

Barnsely Gardens' Woodlands Manor. Though now in ruins, it was a great Italian villa in its day. *Photo by Reese Christian.*

While in Savannah, he fell in love with and married Julia Scarborough, the second daughter of wealthy Savannah shipping merchant, William Scarborough. Together they had eight children: Anna Godwin, Reginald, Harold, Adelaide, Julia, George Scarborough, Lucien and Godfrey Jr. Tragically, Reginald and Godfrey Jr. both died as infants.

Savannah was a cruel place to live in those times, with the harsh summer weather and the constant outbreaks of malaria and yellow fever, so Barnsley decided to move his family to northwest Georgia in what was then Cass County. He had scouted out the land there and had determined that it would be ideal for building a dream home for his beloved Julia and his children. In 1837, Barnsley had picked a piece of land on his several thousand acres that he had acquired and began construction on his Italianate-style mansion, which he would call Woodlands Manor. By 1841, he had moved his family from Savannah to a small, crude cabin that he had built on his land while they awaited the construction of the mansion to be finished.

At the center of the elaborate gardens lies a beautiful fountain. *Photo by Reese Christian.*

The fourteen-room manor would be cutting edge by the standards of the time. It included indoor plumbing, hot and cold running water, flushing toilets and a working rotisserie, as well as many of the most coveted luxuries from around the world. The English garden was designed in the style of Andrew Jackson Downing, who was considered a great landscape architect. The garden was immensely elaborate with every type of rose and many exotic plantings, and it was beautiful.

However, amongst all of this elaborate beauty and luxury, tragedy would take hold and never let go. The land that Barnsley bought was from the Cherokee Indians. When he arrived, he found a tribe member still living on the property and he allowed him to stay and work. Upon learning of Barnsley's plan to build the mansion on a specific piece of land, the Cherokee explained that his ancestors regarded that land as sacred and that he was not to spoil the land without facing the wrath of the Cherokees. Barnsley didn't heed the warning and began construction, and it is said that the Cherokee man placed a dark curse upon the land and then was never heard from again.

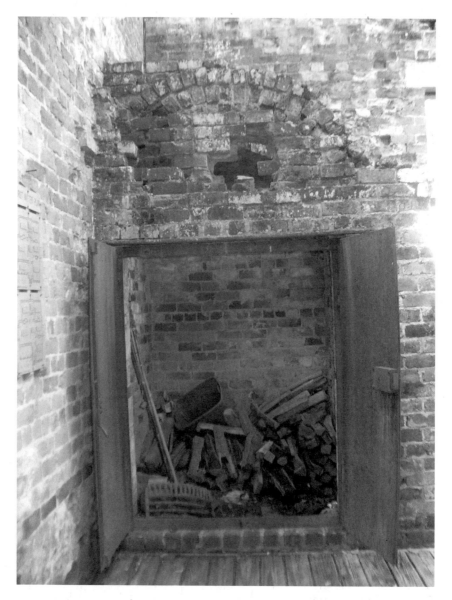

Barnsley's vault once held precious metals, money, jewels and other valuables. Today it holds firewood. *Photo by Reese Christian.*

In 1845, Barnsley's wife Julia contracted tuberculosis after having lost her second infant child. She made the long journey back to Savannah to see her family doctor, but it was too late. Julia died in Savannah, Georgia, in 1845, and she never had the chance to live in her beloved Woodlands Manor.

Barnsley, left broken and lost, stopped construction and abandoned the project when his wife died. Over the next year, he left his six remaining children in the constant care of a governess while he travelled for work and to grieve, but upon his return he saw Julia's spirit by the fountain in the garden. She told him that he needed to finish the mansion for the children, and he attempted to complete it, but with all of the financial and emotional pressures, he never quite succeeded. However, he claimed that he continued to see Julia's ghost on several occasions, both in the home and in the garden.

When Barnsley first scouted land in northwestern Georgia, he was already experiencing financial hardships and they only got worse. After the death of his wife, he began traveling regularly to New Orleans to breathe new life into his cotton business, but then the Civil War occurred and Barnsley sunk what was left of his fortune into Confederate war bonds. The bonds turned out to be worthless and Barnsley was broke. His family lived in posh poverty for the rest of their years. Ironically, the Union soldiers were ordered not to ransack or dismantle the Woodlands Manor, but soldiers from both sides pillaged and plundered the home of all of its prized possessions, food and other items deemed worthy. Just as the Yankee soldiers were about to arrive, Colonel Richard G. Earle of the Confederate army rode to Woodlands Manor in an attempt to warn Barnsley that the Union soldiers were headed his way, but he was shot dead just before reaching the home and is now buried on the grounds.

The cursed Woodlands Manor continued to affect all who lived there. In 1858, the second daughter of Godfrey and the late Julia Barnsley, Adelaide, died within the home just after giving birth to her only child. In 1862, Howard was killed by Chinese pirates as he searched Asia for exotic plant life to complete the garden. George and Lucien, who joined the Rebel cause, immigrated to South America at the end of the war and never returned. Barnsley moved to New Orleans to continue the unsuccessful effort to recoup his fortune and left the manor in the care of his daughter Julia and son-in-law, Colonel Baltzelle. Again, tragedy struck in 1868, when Baltzelle was killed by a falling tree. The widowed Julia took her four-year-old daughter, Adelaide (Addie), to New Orleans to be with her father, and she all but abandoned the mansion.

Julia's spirit would have seen her beloved Woodlands Mansion through the fountain in this view. *Photo by Reese Christian.*

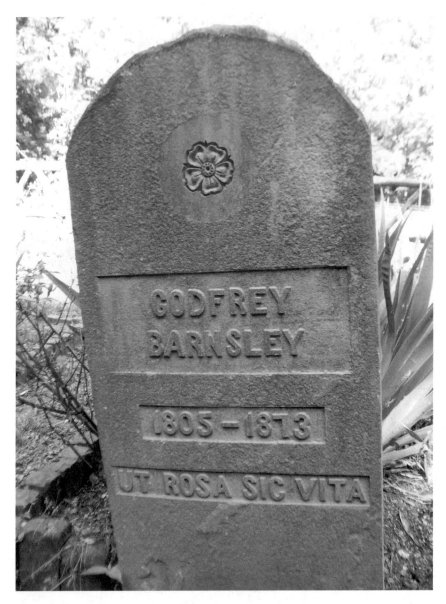

The headstone and grave site of Godfrey Barnsley at Barnsley Gardens. *Photo by Reese Christian.*

The "kitchen" is a separate wing of Woodlands Manor and is in fact approximately twenty-five hundred square feet with a finished basement, making it comparable to a small home. *Photo by Reese Christian.*

In 1873, Barnsley died completely penniless in New Orleans, and Julia brought her father back to Woodlands Manor to bury him. Julia's daughter, Addie, grew up and continued living in the Woodlands Manor home with her husband and two young sons when her husband died an untimely death, carrying out the curse of the mansion.

At some point thereafter a fire occurred in the mansion, but the exact date is unknown. Then, in 1906, a tornado came through and ripped the roof off the home, forcing the family to move into the intact kitchen wing. By 1935, Addie's son, Preston, had become a successful heavyweight boxer known as K.O. Dugan. He was believed to have suffered brain damage from his career of boxing and he was in a mental institution, where he began having delusions that his brother, Harry, was trying to steal his half of the mansion. He then proceeded to break out of the asylum to return to the mansion and shoot and kill his brother. Today there is still a large bloodstain on the hardwood floor in the middle of the

The remnants of the bloodstain from the fatal shooting of Harry Saylor. *Photo by Reese Christian.*

Photo by Reese Christian.

main room where you enter the kitchen wing from the front door. The kitchen is now a museum.

Addie always claimed to see the ghosts of her grandmother, grandfather, mother, son, aunts, uncles and even the colonel who died in an effort to warn them of the Union soldiers. In 1942, Addie died and the manor was sold at auction. It no longer belonged to the Barnsley family. The thousands of acres of the manor became a farm for many years with no apparent curse-induced tragedies plaguing the new family. However, they did not live inside the manor farmhouse.

It is interesting to note that in 1936 Margaret Mitchell published her masterpiece, *Gone with the Wind*, and it is believed that Godfrey Barnsley was one of the models that she used to create the character Rhett Butler.

In 1988, German prince Hubertus Fugger purchased the severely neglected estate and decided to have the curse officially removed. He brought in two Cherokee tribal chiefs who worked in harmony with Spirit to remove the curse, and so it was. Today the Woodlands Manor is called Barnsley Gardens, and it is an elite golf resort with cottages, restaurants, world-class amenities and a spa. The home is in ruins and the old kitchen wing is now a museum, but the gardens have been beautifully restored and tours are offered regularly. And, if you look closely and ask politely, maybe one of the Barnsleys will make an appearance just for you.

THE WREN'S NEST

The Home of Joel Chandler Harris

L ate author Joel Chandler Harris was born December 9, 1845, and died July 3, 1908. He was a journalist who wrote several tales based on African American oral storytelling tradition in the dialect of the slaves of his time. These tales are collectively known as *Uncle Remus*. In the stories, Uncle Remus is an old slave storyteller with children sitting around him listening to his folklore of ethical dilemma and moral fortitude. The main character of the Uncle Remus tales is Br'er (brother) Rabbit, who is a lovable trickster, always finding himself in sticky situations. He is usually the reluctant protagonist, with Br'er Fox and Br'er Bear being the antagonists in his adventures. Another popular character is Tar Baby; although he is not even a living being, he represents the sticky situations that Br'er Rabbit finds himself in and his cunningness to get out of them.

Joel Chandler Harris was an extremely shy man whose fame sat uncomfortably upon him. He was so shy that he often stammered when speaking. He usually referred to himself as an "accidental author." However, he was a strong journalist who promoted change and reconciliation in the New South. Harris published thirty-five books and thousands of articles in his lifetime. Accordingly, in 2000 Harris was inducted as a charter member into the Georgia Writers Hall of Fame.

Harris met and married his love, Esther LaRose, in 1873 while living in Savannah. In 1876 he moved his family north to escape the yellow fever epidemic. Harris had just published his first *Uncle Remus* book before

Joel Chandler Harris's typewriter, spectacles and hat. *Photo courtesy of the Wren's Nest.*

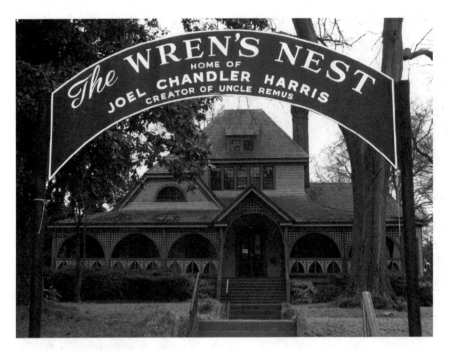

The historic Wren's Nest, home of Joel Chandler Harris, who wrote the *Uncle Remus* tales. *Photo courtesy of the Wren's Nest.*

moving into his final Atlanta home in 1881, which is where he wrote all of his subsequent stories, often on his front porch. He and his beloved Esther had a total of nine children, of which three died of early childhood illnesses in the house. Their names were Mary Esther Harris (1882, age three, diphtheria), Linton Harris (1890, age seven, diphtheria) and Mary Harris (1891, age unknown, died of natural causes). It seems that at least one of them is still very much attached to the home. A ghostly apparition of a boy who is believed to be the son, Linton Harris, is often seen in the house near the stairwell by visiting patrons, psychics and paranormal investigators. The sighting is usually of a young boy dressed in late nineteenth-century fashion who is walking, standing or playing alone in the main hallway near or on the stairs. He doesn't appear to be frightening anyone purposely, and it is often thought that he is trying to get a message to the living from beyond the grave.

In 1900, Harris dubbed his home the Wren's Nest after his children found a wren's nest in the mailbox. They didn't want to disturb the family

These are Joel Chandler Harris's kids that made it to adulthood. They are, *from left*: Julian LaRose Harris, Lillian Harris, Evelyn Harris, Joel Chandler Harris Jr., Lucien Harris and Mildred Harris. *Photo courtesy of the Wren's Nest.*

of birds so in consideration they built another mailbox. The Wren's Nest was Harris's home from 1881 until he died in 1908 of acute nephritis and sclerosis of the liver. Today the home is a museum, and it is Atlanta's oldest house museum, with much of the original furniture and belongings left intact. The room Joel Chandler Harris died in looks exactly the same today as it did the day he passed. The home became a National Historic Landmark in 1962.

Today, the house museum is known less for its ghosts than for its historic and educational values, but as mentioned before, there are plenty of incidents that point to a ghostly presence or two on the premises. The current executive director is Lain Shakespeare; a name I feel is befitting the great-great-great-grandson of Joel Chandler Harris. Shakespeare is a talented writer in his own right and has a bachelor's degree in English.

Joel Chandler Harris's room exactly as it was when he died in his bed. *Photo courtesy of the Wren's Nest.*

There have been several paranormal investigations that have taken place on the premises of the Wren's Nest, and Shakespeare has shared a few of his own firsthand experiences. First, one evening that happened to be Friday the Thirteenth 2007, he was sitting in his office eagerly expecting a group of paranormal investigators (my group—the Ghost Hounds) to arrive to do a ghost hunt on the property, and he claims that "after the conclusion of an unexpectedly intense meeting here in the office, a clock spontaneously detached itself from the wall and rolled under my chair." Shakespeare claims that the incident was very abnormal and scared him profusely. Later that evening, while we were all present in the home and attempting to communicate with the spirits, the doorbell rang. We were standing by the front door and opened it immediately, but there was nobody there. However, there was a homeless man who had found a place of refuge at the far end of the front porch around a corner, and he was sleeping heavily due to being inebriated. He did not ring the doorbell, and we never found anyone in the vicinity who did. Could that have been little Linton playing *ding dong ditch* with us? Shakespeare also has a copy of an electronic voice phenomenon (EVP) recording of a ghost whistling an out-

Chloe, the cook at the Wren's Nest. *Photo courtesy of the Wren's Nest.*

of-tune version of "Baby Bumble Bee." Finally, there is an old lithograph in the basement that is said to have knobs that have turned on their own and without electricity. How frightening!

In the dining room area, the cook, an African American woman by the name of Chloe, is said to still remain in the house moving dishes, blinking the chandelier lights and pining for her former lover—Harris! Yes, it is believed by some that she was the mistress to Joel Chandler Harris.

The Wren's Nest is an incredible museum to visit. Whether you are looking for historic information on the *Uncle Remus* tales or Joel Chandler Harris, or you just want to visit a beautiful haunted old house, you will not leave disappointed. This house and what it represents is a staple of the South, both past and present, and it will aid in keeping our history alive, no matter how dark it may have been.

ABOUT THE AUTHOR

Photo by Roxanne Williams.

Reese Christian is an elite, world-renowned psychic medium, psychic detective and paranormal investigator living in suburban Atlanta, Georgia. She has been featured for her work with Bauder College students cracking cold cases on CNN *Crime*, and her work is spotlighted on the twenty-fifth-anniversary DVD re-edition of Hollywood's *Poltergeist*. She is also regularly featured on a local FM morning radio show entitled, *The Giant Show on Project 9-6-1* on FM 96.1. She is a member of the Cold Case Investigative Research Institute and Ghost Hounds Paranormal Research Society. Reese founded Presage Consultants, a group of professional psychics that includes her mother and older sister and is located in Atlanta, Georgia. This is her first book and more are expected. Visit her website at www.ReeseChristian.com.

Please visit us at
www.historypress.net